IMAGES
of America

SAN FRANCISCO'S
POTRERO HILL

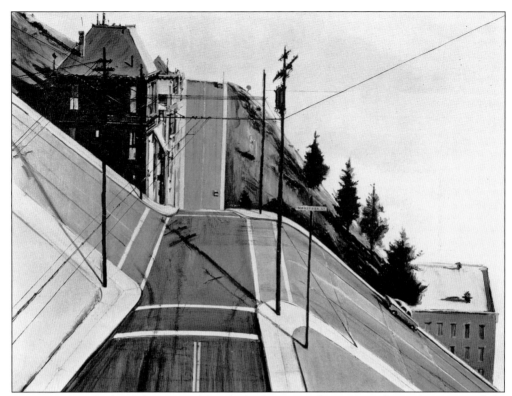

Artist Wayne Thiebaud (born 1920) has had a house on the western slope of Potrero Hill for many years. He became well known for his thickly-painted images of pies and cakes in the early 1960s, and was grouped with the pop artists. However, he sees his artistic concerns as much broader, and has said, "As far as I'm concerned, there is only one study, and that is the way in which things relate to one another." The hills of his neighborhood inspired later paintings. "I was fascinated by those plunging streets," said Thiebaud. Imagination overtakes the laws of perspective and topography in these works, but Potrero Hillers will still recognize sights that seem familiar. Mariposa Street is barely visible on the street sign in this 1977 painting, *24th Street Intersection*. While Twenty-fourth and Mariposa Streets do not actually intersect, Thiebaud gives us a vivid impression of the Hill as a giant roller coaster. A short drive around Potrero Hill affords many dramatic views. (Courtesy Visual Artists & Galleries Association.)

IMAGES
of America

SAN FRANCISCO'S
POTRERO HILL

Peter Linenthal, Abigail Johnston,
and the Potrero Hill Archives Project

ARCADIA
PUBLISHING

Published by Arcadia Publishing
Charleston SC, Chicago IL, Portsmouth NH, San Francisco CA

Printed in the United States of America

Library of Congress Catalog Card Number: 2005923146

For all general information contact Arcadia Publishing at:
Telephone 843-853-2070
Fax 843-853-0044
E-mail sales@arcadiapublishing.com
For customer service and orders:
Toll-Free 1-888-313-2665

Visit us on the Internet at www.arcadiapublishing.com

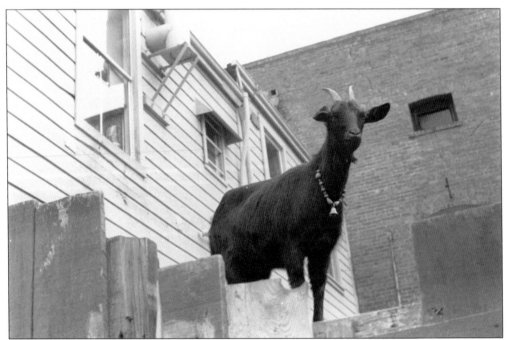

Potrero Hill's most enduring nickname is Goat Hill, and one of its most enduring eateries is Goat Hill Pizza on Connecticut and Eighteenth Streets. From 1978 until 1985, Goat Hilda lived in the pizzeria's backyard where she fed on restaurant leftovers, snacked on anything within reach—she had a particular fondness for rose buds—and raised a couple of kids, Bucky and Loretta. When the popular restaurant ("All You Can Eat" Mondays!) needed the backyard in order to expand, new homes for the goats were found. (Photo by Stephen Fotter.)

CONTENTS

ACKNOWLEDGMENTS

First and foremost, we thank all the generous people of Potrero Hill who have shared their family stories, memorabilia, and photographs with the Potrero Hill Archives Project since its inception in 1986. Without them, this book would not have been possible. Many of their names, stories, and pictures are in the pages that follow.

A host of others contributed to this book, in ways some of them might not even realize. We'd like to thank Philip Anasovich, Anchor Brewing Company, Judy Baston, Julia Bergman, John Borg, Bruce Brugmann of the *San Francisco Bay Guardian*, Chris Campbell of Potrero Mail N' More, Curt Chelin, Flo Cimino, Phil DeAndrade, Dr. Video, Susan Eslick, Stephen Fotter, Greg Gaar, Andrew Galvan, Jon Greenberg of the Potrero Hill Recreation Center, Edward Hatter and Kuzuri Jackson of the Potrero Hill Neighborhood House, Sister Kathleen Healy of St. Teresa's Church, Roger Hillyard of Farley's, Pete Hogg and Phil Bond of Digital Pond, Don Kambic, Glen Koch, Mary Law, Mark Linenthal, Judie Lopez, Kathleen and Bill Manning of Prints Old and Rare in Pacifica, Dave Margulius, Avery McGinn of Klein's Deli, Tee Minot and Trish Keady of Christopher's Books, Milton Newman, Rose Marie Sicoli Ostler, Ruth Passen, Georgette Petropoulos, *The Potrero View*, the staff of the San Francisco Public Library's History Center, Jerry F. Schimmel, Newall Snyder, Martin Spencer-Davies, Kevin Starr, Lorri Ungaretti, Chris VerPlanck, Ralph Wilson, Jensa Wu and the staff of the Potrero Branch Library, Kyle Wyatt of the California State Railway Museum, Linda Yamane, Lester Zeidman, and our patient editors at Arcadia Publishing.

Books that were invaluable in our research include *Vanished Waters* by Nancy Olmsted, *Iron Men* by Richard H. Dillon, *San Francisco Bay* by John Haskell Kemble, *San Francisco: Building the Dream City* by James Beach Alexander and James Lee Heig, *Time of Little Choice* by Randall Milliken, and *Imperial San Francisco* by Gray Brechin, among others.

Like a tapestry, the story of Potrero Hill is made up of many threads. Weaving them together was no easy task. We have made every effort to be accurate, but it was impossible, on the relatively small loom of this book, to be complete. We hope to be able to correct any errors or oversights in future printings.

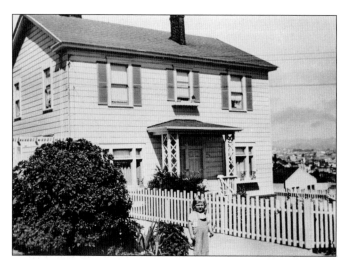

Julia Bergman is shown here in 1949, in front of her childhood home at 690-692 Wisconsin Street, which was built in the early 1870s. In an album of family photographs, Julia's mother labeled this picture "the original de Haro house." As an adult and a librarian, the notation piqued Julia's curiosity, and she embarked on research that has uncovered much of the de Haro family story, so extensive that a book about it is in progress.

FOREWORD

Like Rome and other great cities, San Francisco is a city of villages on hills. Potrero Hill is the quintessential village-on-a-hill, and all phases of San Francisco history have been portrayed on it. In eons past, the hill was wild terrain, across which moved tule elk. Native Americans roamed the area for more than 20 generations. In the Spanish and Mexican era, it was a great cattle ranch. During the gold rush, herds of long-horn cattle, driven north from Southern California, were brought to its base. In the late 19th century, Victorian homes for working people began to spring up on the grid of its streets. By the early 20th century, Potrero Hill supported a flourishing and diverse community representative of international San Francisco. It had become, in fact, a successful neighborhood. During World War II, shipyard workers came to live on the eastern and southern side of the hill in units that, after the war, were turned over the San Francisco Housing Authority.

As a denizen of Potrero Hill from 1950 to 1955, I moved between two worlds. I lived in the Potrero Hill Housing Project at 144 Dakota Street with my mother, a welfare recipient, my younger brother, and a mongrel dog named Shaggy who was secured from the SPCA on Sixteenth Street. On Sundays, I would walk up Dakota Street, past the Potrero Hill Park, then down the hill to St. Teresa's Church for mass. Thus I encountered Potrero Hill as flourishing and traditional along with its more embattled aspects in the housing project.

I felt it a stigma to be living on welfare in the projects, though there were many fine people there. Downstairs from our apartment, for example, lived a retired railroad worker and his wife. I loved to visit them because their home was so cozy and well kept. I also liked reading the latest *Collier's* and *Saturday Evening Post* magazines to which they subscribed. From them, I glimpsed a civility that was not evident in my own household.

For three years I commuted by bus—the 53 Southern Heights to Sixteenth and Bryant, the 47 Potrero to Market Street, and a transfer to another bus down Market—to St. Boniface School in the Tenderloin. I lived in one embattled district of the city and attended school in another, although the Tenderloin was not as scruffy and dangerous 50 years ago as it seems to be now. In 1953 and 1954, I commuted to St. Ignatius School via the 53 Southern Heights, the 47 Potrero, and the 5 McAllister. It was a long trip, and I used every excuse I could to stay overnight at my grandmother's house on Clayton Street near the campus.

What do I remember of Potrero Hill, aside from the distressing details of my personal circumstances? I remember the tremendous views. I remember the thrill of walking down to the piers, smelling the saltwater and fish being taken from the fishing boats unloading their hauls. I loved the industrial buildings, each of them busy with men and women at work. I remember the smell of coffee being roasted at the Hills Brothers factory, or was it the MJB?

In good weather, the ice cream man would come by wearing a white suit and a military-style hat that was also white, pushing a great white cart. Ringing a bell attached to the cart, he would holler, "Ice cream! Ice cream! Get your ice cream!" If I had the money—it cost a dime—I could buy ice cream. If I were even more flush with funds, I could walk over to the Roosevelt Theater on Twenty-fourth Street on the other side of Potrero and see a double feature for about 35¢. Even more adventurously, I could walk over to Mission Street and catch a double feature at the Mission Theater, the Grand, or the El Capitan. I saw hundreds of movies in those years (or so it seems) at these theaters, and at the New Potrero Theater on Connecticut Street, because I wished to be somewhere else.

In later years, Potrero Hill, continuing its paradigmatic course, experienced yet another phase of development with its emergence as a fashion district at its northern base, and on its heights as a gentrified district of attitude and chic. With the exception then of the Native American and rancho years, I have experienced or witnessed vestiges of Potrero Hill in most of its phases: Victorian blue-collar neighborhood; multi-ethnic district of the 1920s; the World War II era as

manifest in defense housing; the urban challenges of poverty and social disorientation in the 1950s, when I lived there; the restoration of neighborhood pride and sense of heritage in the 1960s and 1970s; and the gentrifications of the present.

I wanted to leave Potrero Hill, at least the housing project, which I finally managed to do in the fall of 1955 by entering a Roman Catholic junior seminary. I left the hill behind as a form of suppressed memory. I have been asked to release these memories into the present. I can only scratch the surface, for within those memories—within those four years on Potrero Hill—lurk the inexplicable terror and glory of the past.

—Kevin Starr
California State Librarian Emeritus
and author of the six-volume series *Americans and the California Dream*

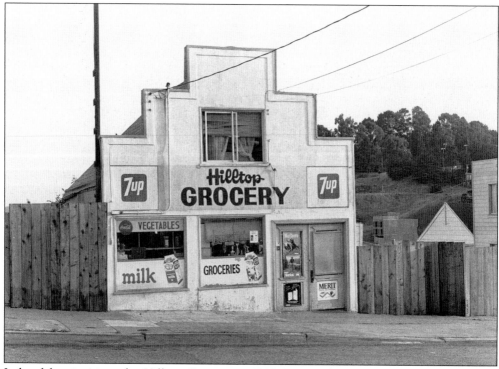

Isolated but inviting, the Hilltop Grocery at 1309 Twentieth Street seems quintessentially Potrero Hill. Built in 1916, it has been owned by Sam and Linda Wong since 1958. (Photo by Stephen Fotter.)

One

IN THE BEGINNING

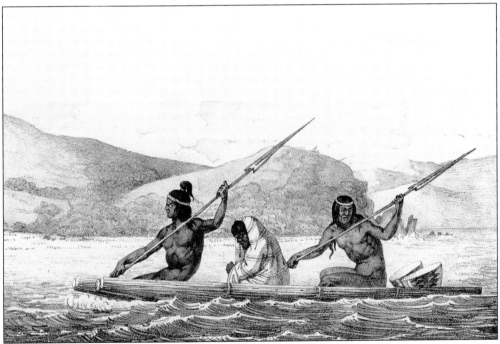

Ohlone Indians were the original inhabitants of the San Francisco peninsula, where they lived a stable life for several thousand years before the coming of white men. Agriculture was unnecessary in an environment so rich in plant and animal life, and Native Americans here moved seasonally between villages following game. They crossed the bay in boats made from bundles of the abundant tule reeds. Boats like these have recently been built again by Ohlone descendants, and are wonderful to see—simple, elegant, and surprisingly stable afloat. A person can easily step along a boat's rounded rim. This early image was drawn by Louis Choris (1795–1828) during an 1815–1816 Russian expedition in quest of a northwest supply route to serve their trading posts in California and Alaska. Notice the geometric pattern on the basket; it was also used in decorations at Mission Dolores painted by the Ohlone. (Courtesy California Historical Society.)

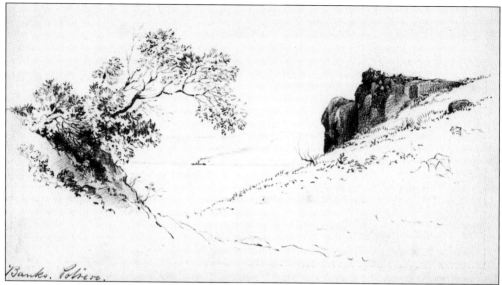

This sketch by Pascal Loomis (1826–1878) shows the banks of Potrero much as they originally looked when the pre-contact Ohlones lived here. (Courtesy Bancroft Library, UC Berkeley.)

Potrero Hill is a huge mass of serpentine—or more precisely serpentinite—a metamorphic rock formed more than 70 million years ago by the collision of the sea floor and the California edge of the Continental Plate. Serpentine contains large amounts of magnesium and iron that leach into the soil, making it toxic to many plants. However, more than 200 varieties can tolerate and even thrive (through adaptation and lack of competition) in serpentine soil, including Leather Oak, Dwarf Flax, San Luis Mariposa Lily, and Soaproot. Serpentine is alleged to alleviate paranoia and enhance psychic abilities. In 1965, it was named California's state rock, the first in the United States to be so honored. Serpentine can be seen in Hill basements, construction sites, and remaining open spaces, such as this one at Twenty-fourth and De Haro Streets. (Photo by Peter Linenthal.)

The California buckeye is native to Potrero Hill. This venerable specimen thrives at the Caltrain station at Twenty-second and Pennsylvania Streets. The seeds are dark brown with a tan spot on one end, giving them the look of a deer's eye. Buckeyes are poisonous, but the Ohlones boiled them to leach out their toxins when acorns were scarce. They also added crushed buckeyes to creeks and streams, which stupefied fish and made them easy to catch. (Photo by Peter Linenthal.)

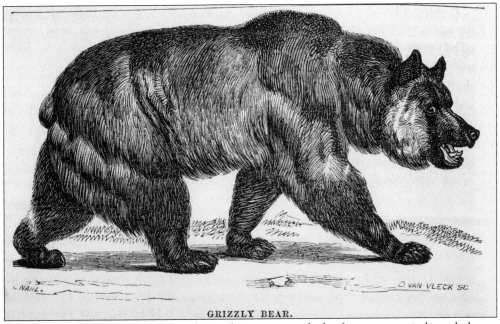

GRIZZLY BEAR.

The Bay Area was rich in wildlife. Pelicans, herons, geese, ducks, foxes, mountain lions, bobcats, deer, elk, antelope, and grizzly bears were plentiful. As late as 1850, there was a report of a grizzly wandering into Mission Dolores. (Courtesy Society of California Pioneers.)

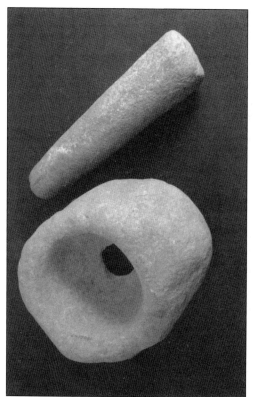

More than 400 Native American shell mounds were located along the shores of the bay by Nels Nelson in 1906. They are estimated to be between 2,000 and 5,000 years old and contain shells, ash, charcoal, tools, artifacts, and bones—both animal and human. Typically oval, shell mounds vary in length from 30 to 600 feet. In the photograph below, Nelson's crew excavates a 520-foot-long mound near Candlestick Point. The mortar and pestle (shown at left), used to grind food staples such as acorns and seeds, were found there just south of Potrero Hill. Today, shell mound preservation often becomes an issue when development or treasure seekers threaten the mounds. (Courtesy Phoebe Hearst Museum of Anthropology, UC Berkeley.)

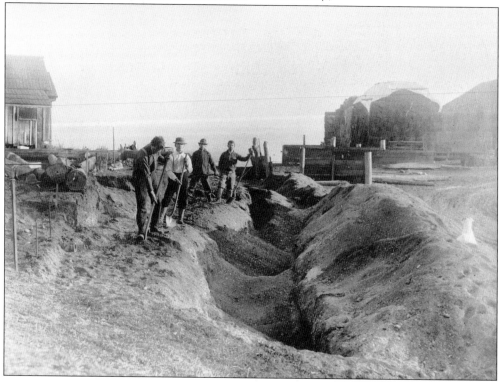

Ohlone houses were domed and made from tule mats tied to a willow framework. This traditional house was built in 2001 in the garden of Mission Dolores by Jakki Kehl (Mutsun Ohlone), Linda Yamani (Rumsien Ohlone), Mike Bonillas (Mutsun/Rumsien Ohlone), and Juanita Ingalls (Mutson Ohlone). Most villages consisted of several houses shared by one or more families, and were built near the shore of a bay, lake, stream, or creek. Several villages would constitute a tribelet, with as many as 250 people, which identified itself with its hunting and gathering lands. Border disputes with neighboring tribes were sometimes settled with bow and arrow. In the late 1700s, the Yelamu, an Ohlone tribelet of no more than 160 people, had two villages on Mission Creek just north of Potrero Hill. They moved seasonally between Sitlintac on the bay shore and Chutchui near where Mission Dolores stands today. (Photo by Peter Linenthal.)

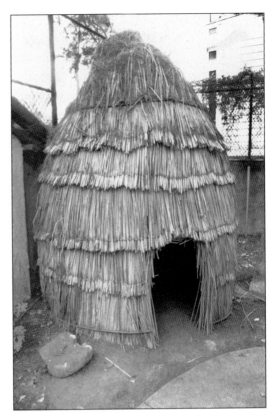

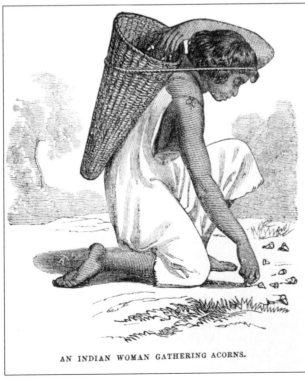

AN INDIAN WOMAN GATHERING ACORNS.

A Native American woman gathers acorns using a burden basket in this 1859 illustration from *Hutchings' California Magazine*. Grass seeds were another important food. The Ohlone burned certain fields, stimulating the seed supply. This carefully managed food source was almost destroyed by mission cattle, a great blow to traditional Ohlone life. The woman wears mission-period clothing, which suggests that traditional food gathering continued after the arrival of the Spanish. (Courtesy Society of California Pioneers.)

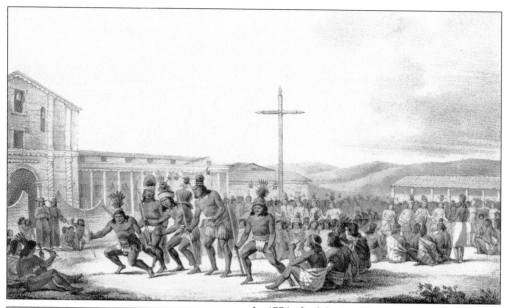

In 1776, the Mission San Francisco de Asis was founded near a lake, which earlier that year explorer Juan Bautista de Anza had named *Laguna de Nuestra Senora de los Dolores*, or "Lake of Our Lady of the Sorrows." Roughly bordered by Fifteenth, Nineteenth, Guerrero, and Howard Streets, Mission Dolores (as it came to be known) was the sixth of 21 missions established by Franciscan padres with the aim of converting the Native Americans to Christianity. It was the first permanent evidence of white man's settlement of the area they called Yerba Buena (the name of the settlement was changed to San Francisco in 1847). This lithograph, based on an 1816 sketch by Louis Choris, is the oldest known image of Mission Dolores. (Courtesy California Historical Society.)

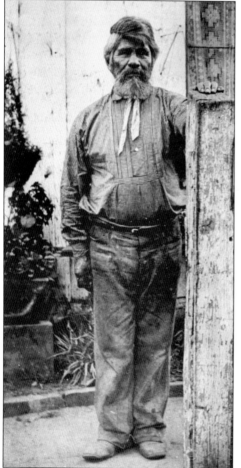

Pedro Evencio was an Ohlone Indian of the Raymaytush tribe who was born on the San Francisco peninsula about 1826. He married a Patwin woman named Pastora at Mission Dolores in 1846. This portrait, taken in 1894, is the only known photograph of someone who lived at Mission Dolores during the time of the padres. It is not known if Pedro Evencio has any living descendants. (Courtesy San Mateo County History Museum.)

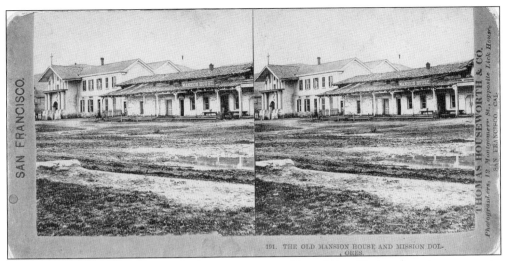

The original mission building, which was constructed by mission Native American converts, is at the far left. By 1865, when this stereoscopic slide was made, the missions had fallen into decline and had been secularized. The Mansion House saloon, at right, was known for its powerful milk punch.

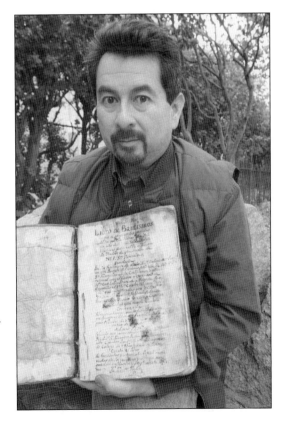

On November 18, 1801, a 14-year-old Bay Miwok Indian named Liberato Culpecse was baptized at Mission Dolores along with other members of his tribe. Liberato Culpecse's great-great-great grandson, Andrew Galvan, holds the original leather-bound register that records that baptism. In 2004, Galvan became curator of Mission Dolores, the first person of mission Native American ancestry to hold such a position. Galvan is often called upon to excavate and study newly discovered Native American sites. He points out that the mission was built and populated primarily by Native Americans and vows to make their story and contributions to the mission better known. The Ohlone tribe was considered extinct, but today descendants are working hard for federal recognition. The Galvan family administers the Ohlone graveyard in Fremont, California. (Photo by Peter Linenthal.)

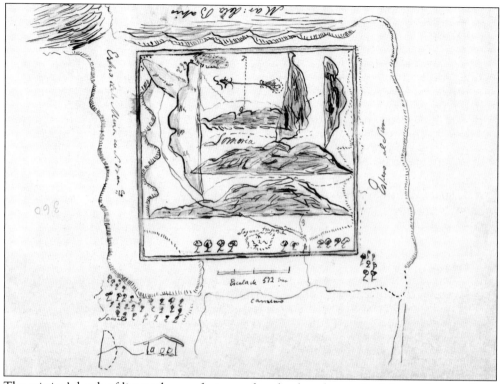

The mission's herds of livestock were first grazed on land to the south of the settlement. Soon more land was needed and then found just east of it, on what is now known as Potrero Hill. The pastures were called Potrero Viejo and Potrero Nuevo—the Old Pasture and the New Pasture. At the time, Potrero Nuevo was a virtual peninsula, with two bays defining its northern and southern boundaries. The Indians of the mission were ordered to build a stone wall just west of the hill to completely enclose the grazing lands. After Mexico became independent of Spain in 1821, the missions were a painful reminder of Spanish authority. The solution was a period of secularization, lasting from 1833 to 1859. Instead of giving the land to the Native Americans, which was the original intention of the missions, land grants were made to Californios, adding to the ranchos of these well-to-do Mexican and Spanish settlers. *Diseños* (drawings) were simple maps required in the Mexican land-granting process. The one above describes the Potrero Nuevo land granted in 1844 to the twin sons of Francisco de Haro to pasture their cattle, with the provision that it be occupied within a year. On the left, Mission Creek flows from the bay toward a willow grove, with Lake Dolores and Mission Dolores at the lower left. Islais Creek is on the right. (Courtesy California State Library.)

The Mission Dolores brand (*hierro*), at far left, and the earmark (*señal*) were used to identify the cattle kept in the Potreros.

Francisco de Haro was born in Mexico in 1792 and came to Yerba Buena in 1819 as a sub-lieutenant in the Mexican infantry. He married Emiliana Sanchez at Mission Dolores and they had 12 children, including twin sons, Francisco and Ramon, who were born in 1827. De Haro was the first Californio *alcalde* (mayor) of San Francisco and served two one-year terms between 1834 and 1839. Just two years after his sons were granted the Potrero Nuevo land in 1844, they were killed by Col. John C. Fremont's men near San Rafael. The flourish under his name below was his rubric, an identifying mark. (Courtesy San Francisco History Center, San Francisco Public Library.)

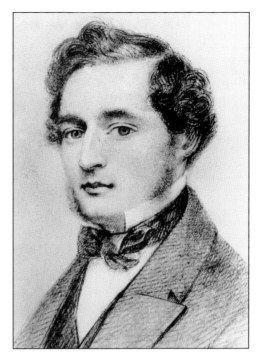

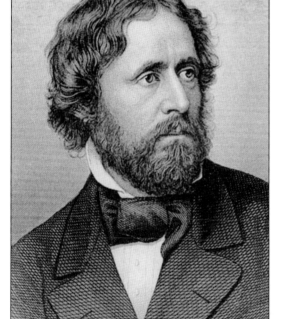

In 1846, Col. John C. Fremont came to California on a "surveying expedition," with Kit Carson as his guide. Later that year, the United States declared war on Mexico. When Fremont met up with the 19-year-old de Haro twins, Francisco and Ramon, and their uncle Jose Berreyesa at Point San Pedro in Marin, he suspected them of carrying a message for the Mexican military. He ordered Kit Carson to shoot all three of them and strip them of their clothing. Fremont would go on to a career as a senator, but when he ran for president in 1856, the de Haro case and other instances of taking the law into his own hands during the war with Mexico were used against him. He lost his bid for the presidency to James Buchanan, and did not mention the de Haro twins in his autobiography.

17

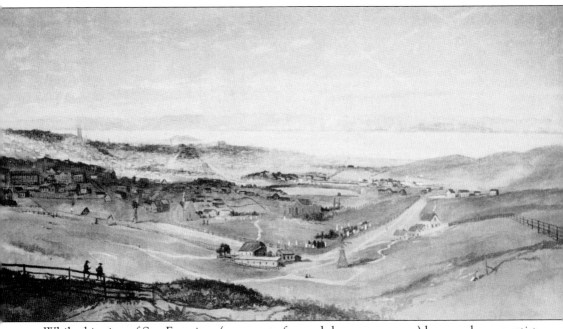

While this view of San Francisco (once part of a much larger panorama) by an unknown artist was painted about 1870, it shows Potrero Hill—silhouetted against the bay at the right—looking decidedly rural. In the middle ground is Mission Dolores and behind it Lake Dolores. Two Jewish cemeteries occupy what is now Dolores Park. A stream that flowed down from Twin Peaks and followed the line of Eighteenth Street fed the lagoon. By 1873, the lagoon, then known as Lake McCoppin, covered about a block bounded by Guerrero and Dolores Streets from Eighteenth Street to Nineteenth. Soon it was filled in completely; a wooden sewer carried off surplus water to Mission Creek.

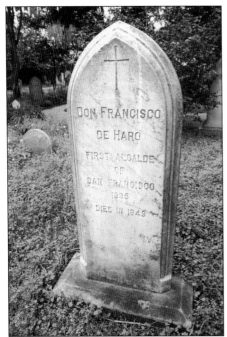

Francisco de Haro, grief stricken over the murder of his twin sons by Colonel Fremont's men, retired to the family ranchero by Lake Merced, where he died in 1849. Here is his tombstone in the cemetery at Mission Dolores, where he is buried with other early settlers including members of the Arguello, Bernal, Noe, and Sanchez families and more than 6,000 Native Americans. The story of these people is often neglected in histories of early San Francisco, which tend to focus on the military post of the Presidio and the village of Yerba Buena.

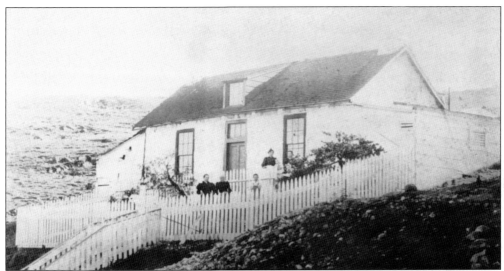

This adobe house (shown in 1900 behind what is now 1929 Twentieth near De Haro Street) was certainly one of the first buildings on Potrero Hill. Adobe bricks made by the Ohlone at Mission Dolores may have been used in its construction. It is also possible that it was used by members of the de Haro family in the 1850s when they held the grant to Potrero Nuevo. It was torn down in the early 1920s. (Courtesy California Historical Society.)

The discovery of gold in 1848 transformed San Francisco from a small town—with a population of only 459 in 1847—to a world seaport almost overnight. By 1850, when California joined the United States, San Francisco's population had burgeoned to over 30,000. Land values shot up, and speculators turned their eyes toward Potrero Hill. In 1849, John Townsend and Cornelius de Boom laid out lots on the flat lands of Potrero Nuevo just south of Mission Bay. But not many lots were sold—Potrero Nuevo was just too remote and inaccessible. In 1856, auctioneer John Middleton staged a sale of "the entire tract of land known as the Potrero Nuevo," even though the de Haro family's claim to the Hill's 2,288 acres was still in the courts and would be until 1878.

NOTICE.

The sale of the POTRERO LANDS will re-commence at 2 o'clock, P. M., THIS DAY, according to notice at the close of the sale yesterday. au5

THIS DAY,

WEDNESDAY,.............August 6, 1856

GREAT SALE OF REAL ESTATE.

The Largest and Most Important Sale
EVER MADE IN THE
City of San Francisco.

SALE OF THE ENTIRE TRACT OF LAND
KNOWN AS THE
POTRERO NUEVO,
WILL BE HELD AT THE
Auction Rooms of John Middleton,
CORNER OF CALIFORNIA AND MONTGOMERY STS.,
At 10 o'clock, A. M.,

SALE TO BE POSITIVE AND WITHOUT RESERVE

A Full Description of the Subdivision, and Printed Catalogues of the Property, can be had at the Auction Rooms two weeks before the Day of Sale.

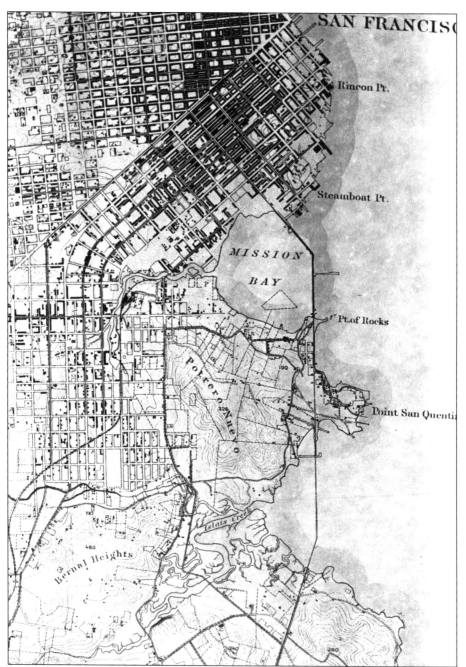

"This city is growing southward," reported the *Alta California* on May 2, 1864. This expansion required that the Potrero Nuevo be made more accessible. The solution was to build a bridge across Mission Bay, linking the city's commercial center to the Potrero and points south. Suddenly, Potrero Hill was no longer an isolated peninsula, it was prime real estate. An era of intense land speculation had begun. This United States Coast Survey map was published in 1869 and still identifies Potrero Hill as Potrero Nuevo. Both Mission Creek, west of Mission Bay, and Islais Creek, defining Potrero Nuevo's southern boundary, still extend far inland. Mission Bay has not yet been filled in, but the bridge spanning it (see next chapter) was the beginning of the end.

Two

ON THE WATERFRONT

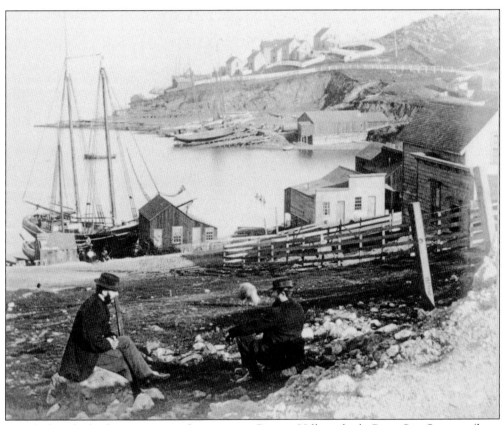

Even before the bridge connecting downtown to Potrero Hill was built, Point San Quentin (later known as Potrero Point) was developing as an industrial area. It had a deep-water port with ideal access for ships. The gold rush led to a need for gunpowder, which was used for hard rock mining in the Sierras. As a city ordinance prohibited dangerous industries from locating anywhere near residential areas, two gunpowder manufacturers established facilities at Potrero Point in the 1850s—E. I. du Pont de Nemours Company, near what is now the corner of Maryland and Humboldt Streets, and Hazard Powder Company, on what is now Twenty-third Street between Maryland and Louisiana Streets. Eadweard Muybridge took this *c.* 1862 photograph of Point San Quentin, looking east from about Illinois and Nineteenth Streets toward early houses on Irish Hill. (Courtesy Bancroft Library, UC Berkeley.)

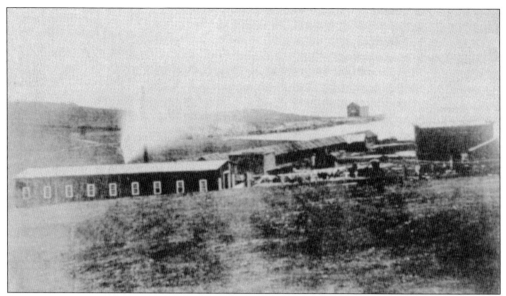

Rope was essential to the shipbuilding industries growing on and near Potrero Hill. In 1856, brothers Alfred and Hiram Tubbs established San Francisco Cordage Manufactory just south of Point San Quentin. The pioneering rope factory was located on a parcel bounded roughly by Iowa, Kentucky (Third), Twenty-second, and Twenty-third Streets. The plant's 1,000-foot-long ropewalk produced the first rope ever manufactured west of New England. By the 1880s, the factory, renamed Tubbs Cordage Company, employed more than 100 men, and made 2,000 tons of rope a year with some lines 10 miles long. In the 1850s photograph above, the noon whistle blows at Tubbs Cordage. (From *Men of Rope* by David W. Ryder.)

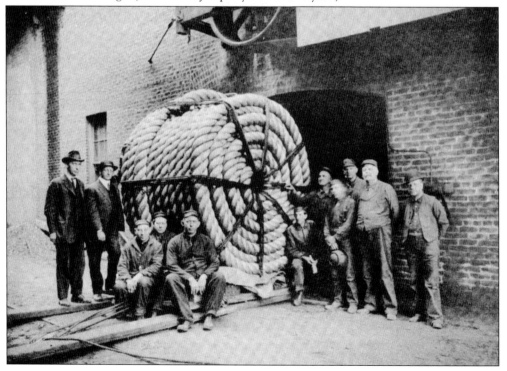

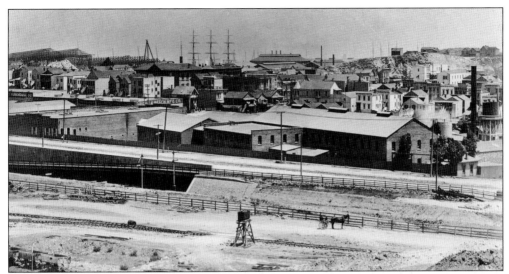

By the 1890s, when this photograph was taken, the southeast waterfront was bustling with shipbuilding and industry. Joining Tubbs on Potrero Point were Pacific Rolling Mills (1868), Arctic Oil Works, Southern Pacific Cattle Yards, Atlas Iron Works, San Francisco Gas Light Company, California Sugar Refinery (1884), California Barrel Company (1884), and Union Iron Works (1883). In the middle ground, just beyond the viaduct, are the buildings of Tubbs Cordage Company. At the far right, at the end of the long building, is the superintendent's office. In the background, Union Iron Works is silhouetted on the left and Irish Hill (where many workers lived) on the right. (Courtesy San Francisco Maritime National Historic Park.)

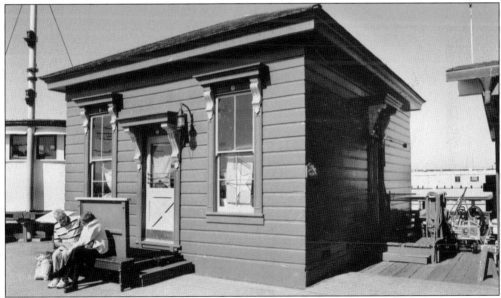

This building was the superintendent's office at the Tubbs Cordage Company. Built in the 1850s, it can be seen now at the Hyde Street Pier as part of the San Francisco Maritime National Historic Park. The company offices were at Indiana and Humboldt Streets. Today, Tubbs Street follows the general path of the 1,000-foot ropewalk building. The clubhouse of the San Francisco Hells Angels Motorcycle Club can be found at Tubbs and Tennessee Streets. (Photo by Peter Linenthal.)

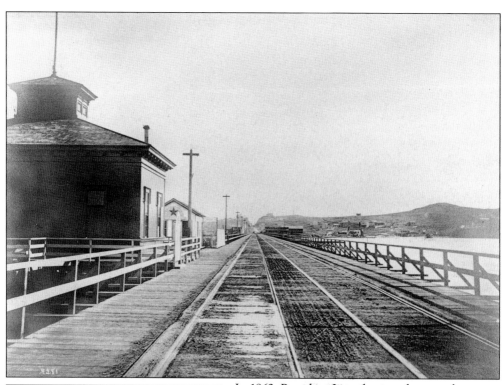

In 1862, President Lincoln signed an act that gave generous subsidies for the building of a transcontinental railroad. In anticipation of an economic boom that trains would bring, construction of a bridge spanning Mission Bay began in 1865 to make the city's remote southern industrial areas accessible by rail. Eadweard Muybridge took this photograph of the new Long Bridge in 1867. Horsecars on the iron tracks of the Bay View Railroad could now cross Mission Bay to Potrero Hill. A southern extension of the bridge crossed Islais Creek Cove to the Bay View Racetrack at the end of the line. (Courtesy San Francisco History Center, San Francisco Public Library.)

The completion of Long Bridge focused attention on the prime real estate it enclosed along the progressively filled-in waters of Mission Bay. Speculation schemes included "Montgomery Street Straight!" The idea was to connect the financial district to the Potrero—Montgomery Street to Connecticut Street—with a broad avenue. In this document, businessmen organize opposition, presumably because it would disrupt their already established businesses. The extension was ultimately defeated, due chiefly to a flaw in drafting the scheme's map.

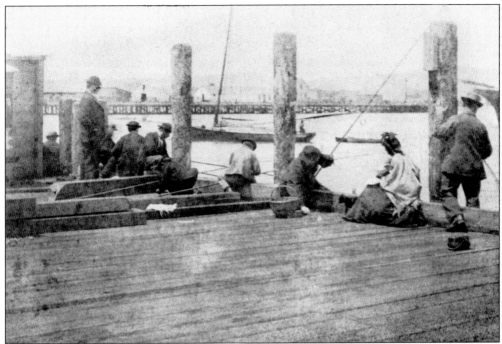

The growth of industry in the Potrero and points south was greatly facilitated by the completion of Long Bridge. Long Bridge also became a destination for recreation. Cafes, saloons, and a yacht club for the well-to-do were located there, and families came to rent poles, buy bait, and fish for smelt over its sides. (Courtesy California State Library.)

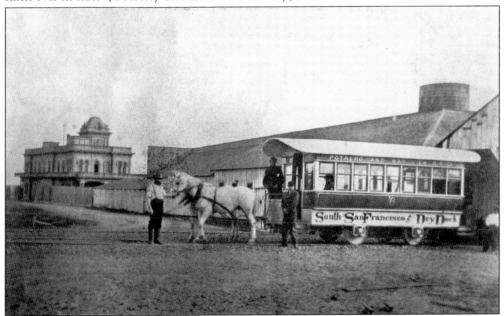

The Potrero and Bayview Railway operated horse-drawn cars on Long Bridge. This photograph probably shows the southern end of the line, where passengers got off for the Bay View Racetrack, and to look at sites advertised by homestead associations. (Courtesy San Francisco History Center, San Francisco Public Library.)

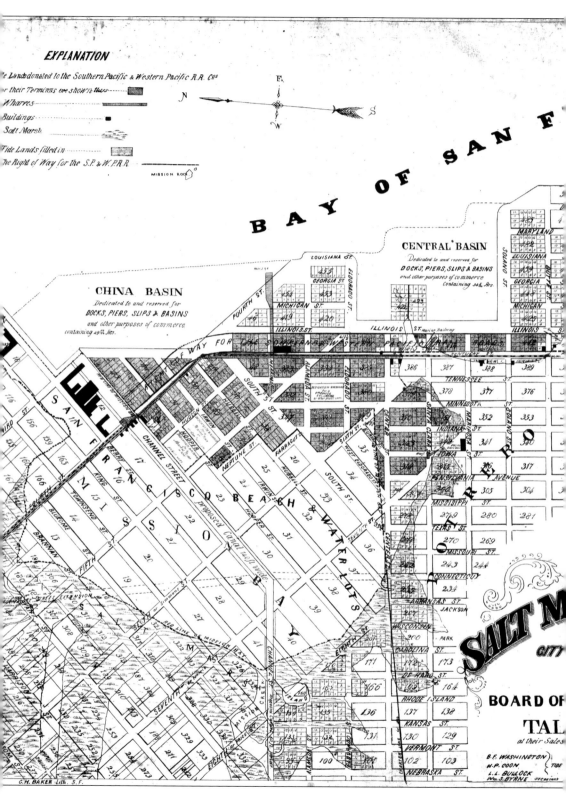

EXPLANATION

The Lands donated to the Southern Pacific & Western Pacific R.R. Cos
or their Terminus are shown thus

Wharves

Buildings

Salt Marsh

Tide Lands filled in

The Right of Way for the S.P. & W.P.R.R.

MISSION ROCK

BAY OF SAN F

CHINA BASIN

Dedicated to and reserved for
DOCKS, PIERS, SLIPS & BASINS
and other purposes of commerce
containing 49¾ Acs.

CENTRAL BASIN

Dedicated to and reserved for
DOCKS, PIERS, SLIPS & BASINS
and other purposes of commerce
Containing 34½ Acs.

MARYLAND

LOUISIANA ST.

GEORGIA ST.

ELDORADO ST.

MICHIGAN ST.

ILLINOIS ST.

TENNESSEE ST.

MINNESOTA ST.

INDIANA ST.

IOWA ST.

PENNSYLVANIA AVENUE

MISSISSIPPI ST.

TEXAS ST.

MISSOURI ST.

CONNECTICUT ST.

ARKANSAS ST.
JACKSON

WISCONSIN ST.
PARK

CAROLINA ST.

DE HARO ST.

RHODE ISLAND ST.

KANSAS ST.

VERMONT ST.

NEBRASKA ST.

SAIN FRANCISCO

CHANNEL STREET

SOUTH SAN FRANCISCO BEACH & WATER LOTS

CHANNEL

MISSION BAY

SALT M

CITY

BOARD OF

TAL

at their Sales

B.F. WASHINGTON
H.P. COON
L.L. BULLOCK
Wm S. BYRNE Secretary

G.H. BAKER Lith. S.F.

26

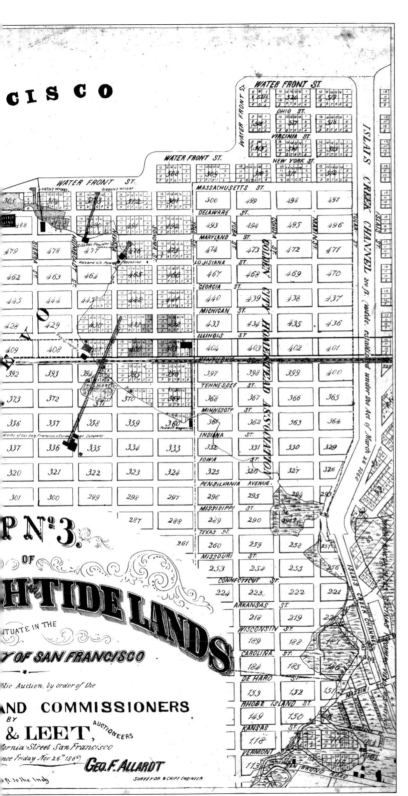

The completion of the transcontinental railroad in 1869 was called "the great event of the age." It brought increased land speculation to the Hill. Even lots that remained underwater were sold, and the filling in of Mission Bay sped up. Note the original shoreline of the 1850s under the grid of proposed streets on this land auction map of 1869, the gunpowder factories south of Pacific Rolling Mills, and the ropewalk and wharf of Tubbs Cordage on the south end of Kentucky (Third) Street. (Courtesy Bancroft Library, UC Berkeley.)

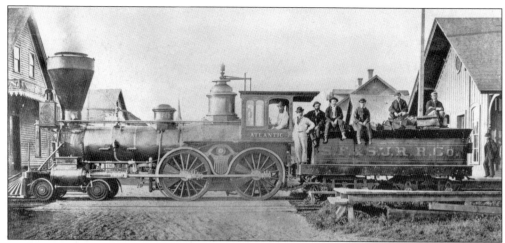

The San Francisco & San Jose Railroad began the first regular passenger service between the two cities in January 1864. Its San Francisco terminus was at Eighteenth and Valencia Streets; its tracks were west of the Hill. Here is locomotive No. 7, the *Atlantic*, in 1865. It was designed and built by Union Iron Works' Irving M. Scott. The SF&SJRR was absorbed by Southern Pacific Railroad in 1870. (Courtesy California State Railroad Museum.)

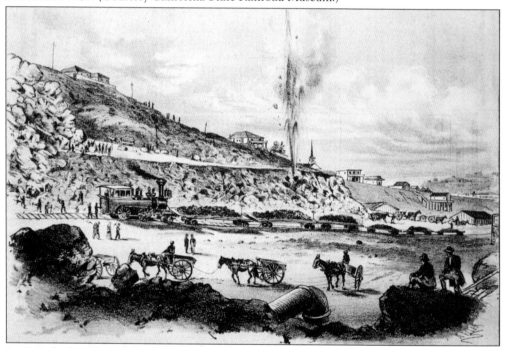

In 1867, the first Potrero Cut leveled Kentucky (Third) Street for horsecar tracks continuing south from Long Bridge. In the 1870s, the Southern Pacific Railroad purchased land for right-of-way along the shoreline of the bay. This lithograph, "The 'Potrero Cut' of the S.P.R.R.," from the February 2, 1878, issue of the *San Francisco Illustrated Wasp*, shows that cut between Illinois and Kentucky Streets being enlarged—the workmen were paid $1 a day. The route down the peninsula remained west of the Hill until construction of the Bay Shore Cut-off was completed in 1907 at a cost of nearly $1 million per mile. The project involved the boring of five tunnels. The Caltrain station at Pennsylvania and Twenty-second Streets is at the southern end of Tunnel No. 1.

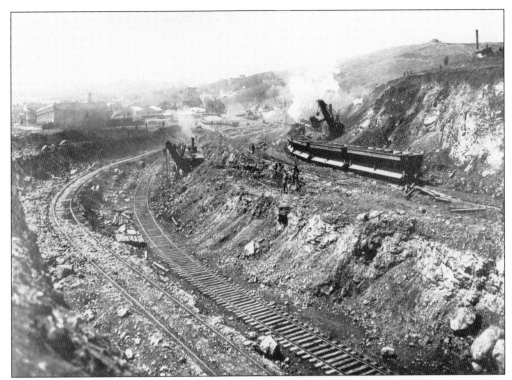

In 1904, the Santa Fe Railroad also cut into the eastern side of the Hill. Steam shovels loaded railroad cars with 1.5 million cubic yards of earth and rock to use as fill at Mission Bay's China Basin, where the Santa Fe was constructing a yard. New tracks laid along this cut included spurs to the expanding industries along the waterfront like the Arctic Oil Works, the Union and Risdon Iron Works, the barrel factory, and the Spreckles Sugar Refinery. (Courtesy California State Railroad Museum.)

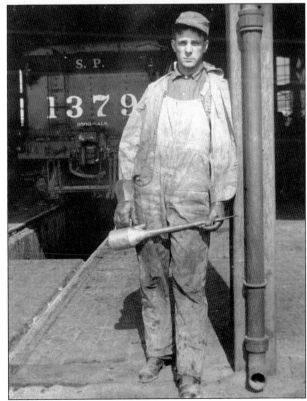

This *c.* 1906 photograph depicts a Southern Pacific railroad worker with his oilcan at the company's roundhouse on Mariposa and Tennessee Streets. (Courtesy Dave Margulius.)

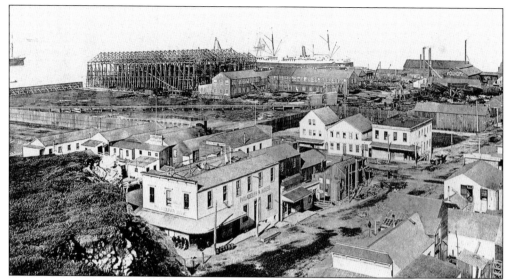

Taken from a rocky outcropping west of Kentucky Street that no longer exists, this 1890s view looking east joins the photograph at right to form a panorama. Twentieth Street between Kentucky and Illinois Streets, at the lower right, was lined with the boardinghouses, restaurants, and saloons that served workers employed at the nearby industries. (Courtesy San Francisco Maritime National Historical Park.)

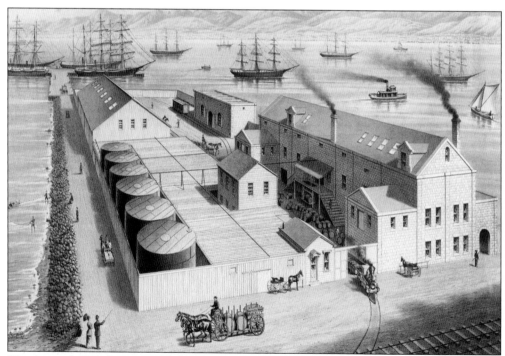

The Arctic Oil Works was established at Illinois and Center (Sixteenth) Streets in 1884. Between 1885 and 1905, San Francisco was the world's principal whaling port. As use of petroleum and spring steel increased, the demand for whale oil and whalebone declined. (Courtesy Bancroft Library, UC Berkeley.)

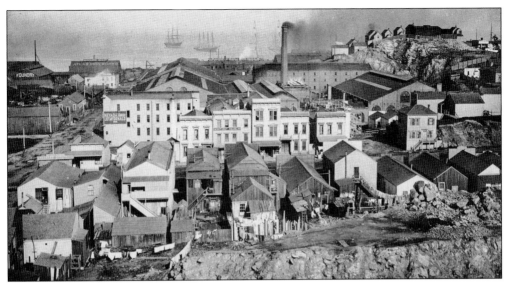

In the background of this photograph, and of the photograph to the left, are the plants, slips, and smokestacks of Union Iron Works, Atlas Iron Works, and Pacific Rolling Mills. The highest point of Irish Hill, reached by 98 wooden steps, is at the far right. All that remains is a small serpentine hummock at Illinois and Twenty-second Streets. (Courtesy San Francisco Maritime National Historical Park.)

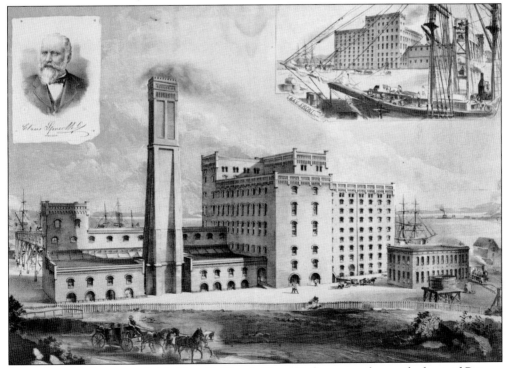

Claus Spreckles's massive brick New California Sugar Refinery on the south shore of Potrero Point was the tallest building in the city in the late 1890s. The refinery employed 1,000 men, or 10 to 15 percent of the neighborhood's workforce. It was torn down in 1951. (Courtesy Bancroft Library, UC Berkeley.)

This firehouse at 1009 Tennessee Street, near Twenty-first Street, was built to serve residents of Irish Hill and Dutchman's Flat (known today as Dogpatch). A handwritten inscription on this photograph notes that it is the "First Picture of Engine Co. No. 16, S.F.F.D., 1884." The site is now a paved lot. In 1925, a new firehouse was built at 909 Tennessee Street; today, the San Francisco Fire Department uses it for storage. (Courtesy Judie Lopez.)

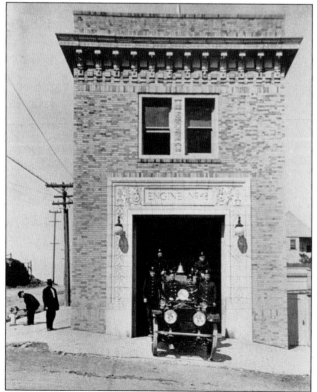

Engine Company No. 48 (now Station 37) was built at 798 Wisconsin Street in 1914, during the post-earthquake building boom. Seen here shortly after it opened, the building was designed by city architect John Reid Jr. and includes intricate terra-cotta tiles. (Courtesy San Francisco Department of Public Works.)

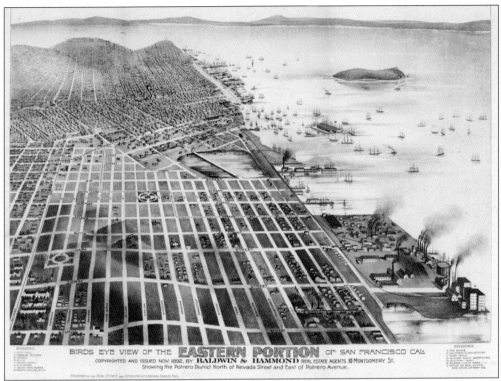

This 1892 "map," circulated by a real estate company, shows the Hill as almost flat, perhaps in an attempt to make the land look more attractive to potential developers. More accurately shown are the industries at Potrero Point and Mission Bay, just east of the tidy grid of streets. Not shown is "Dumpville," an informal garbage dump that by 1895 covered 20 acres south of Channel Street (Mission Creek) and which received 399 wagon loads of south-of-Market garbage a day. (Courtesy Bancroft Library, UC Berkeley.)

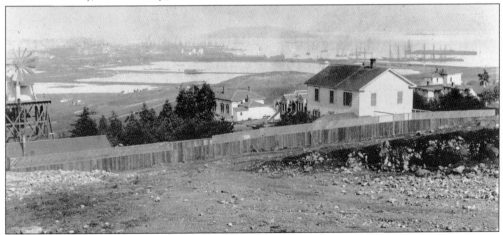

This is a c. 1892 view of Mission Bay from Wisconsin Street south of Napa (Twentieth) Street. In the foreground (right to left) are 690-692 Wisconsin Street, 617-615 Wisconsin Street, and the Ramon/Hawes house (1754 Twentieth Street), known today for the lush plantings that have almost obscured it from view. To the east is the rear of the La Grande house, 467 Mississippi. (Courtesy California Historical Society.)

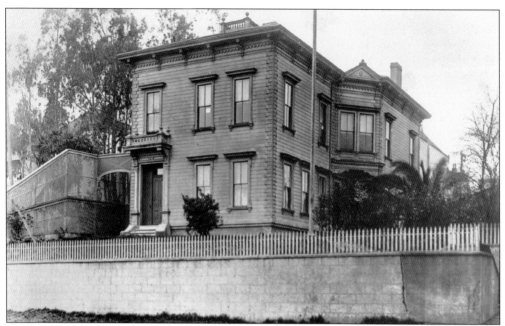

In the 1850s, wealthy sea captain Charles Francis Adams came to San Francisco from New Bedford, Massachusetts, and purchased a 13-acre tract on the northeast slope on which some of the Hill's first fine homes were built. Still standing are three on Pennsylvania Street: the Crowell house (built in 1870 and shown above) at Nineteenth Street; the Richards house (1866), and the Adams family's own house (shown below) at Eighteenth Street. The Adams house was built in 1868 using some shipbuilding techniques and featuring a widow's walk—a small deck on top of the house from which ships on the bay could be observed. (Courtesy Iaconi family.)

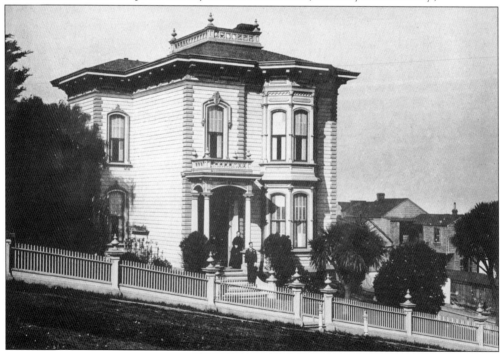

Shown here on May 28, 1893, are Charles F. Adams Jr. and his wife Elizabeth Cairns Adams. In the 1960s, the Iaconi family bought the Adams house, complete with its original furniture and Adams family possessions, from Elizabeth Adams, who was then in her 80s. The Iaconis have been its careful restorers and custodians ever since. (Courtesy Iaconi family.)

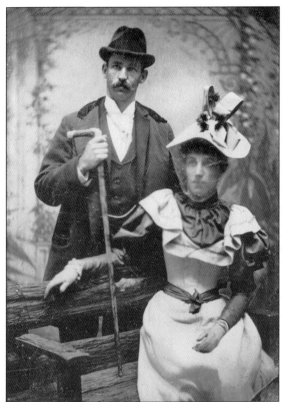

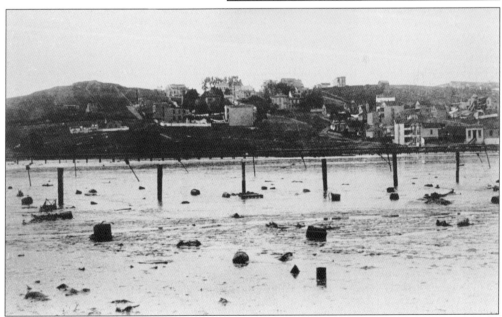

This 1893 view looking west from San Francisco Bay shows Potrero Hill as a knobby peninsula south of the tidelands and salt flats of Mission Bay. The authors have been told that the Adams tract and house (as well as a dairy farm at the lower left) can be seen here. (Courtesy California Historical Society.)

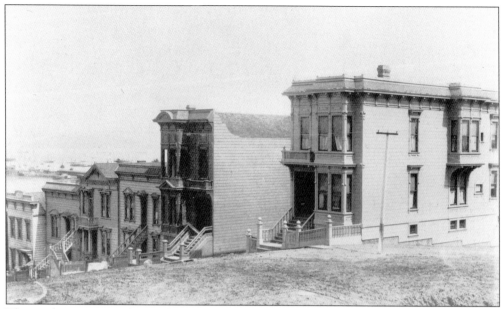

The northeast corner of Butte (Nineteenth) and Mississippi Streets looks much the same today as it did in 1892. However, what sidewalks existed then were made of wood, and the streets were unpaved. Some would say the streets are once again unpaved, as the Hill has been undergoing a major underground project in recent years, involving tearing up pavement to install utility lines below. (Courtesy California Historical Society.)

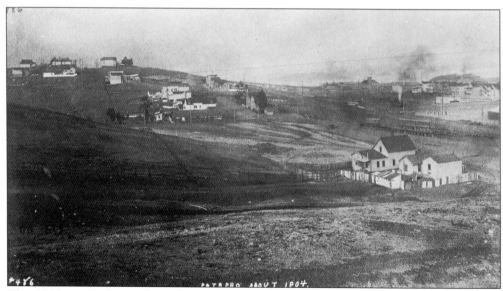

This 1904 view looks northeast from about Texas and Twenty-fifth Streets. The steeple of St. Teresa's Church at its Nineteenth and Tennessee Streets location is visible on the horizon at the right. Further right, the scaffolding at Union Iron Works can be seen. (Courtesy San Francisco History Center, San Francisco Public Library.)

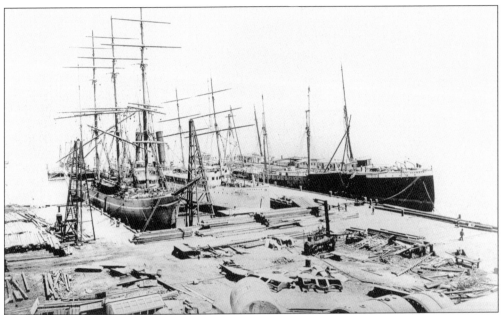

Risdon Iron Works acquired Pacific Rolling Mills, and in 1901 moved its operation to Twentieth and Louisiana Streets. Risdon built the first compound engine in the country, was awarded patents for mining machinery, produced boilers and ship parts, and created pipe for the Spring Valley Water Company. Bethlehem Steel bought out Risdon in 1911 and merged the plant with Union Iron Works.

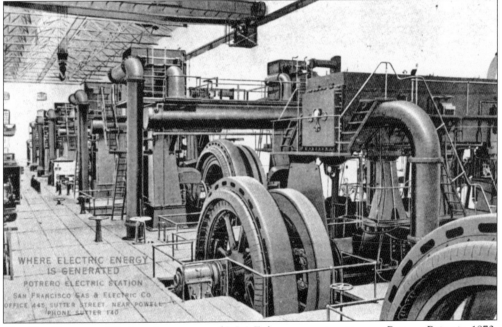

City Gas Company Works, a forerunner of PG&E, began construction on Potrero Point in 1870. By the time of this undated postcard, showing the interior of the Potrero electric station on the corner of Twenty-second and Georgia Streets, the company's name had been changed to the San Francisco Gas and Electric Company. (Courtesy Glen Koch.)

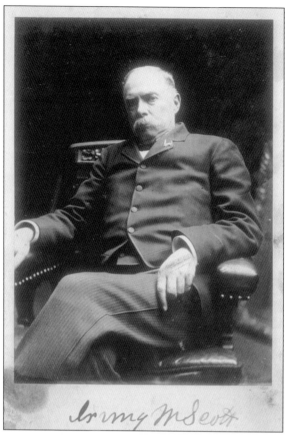

During the gold rush, brothers James and Peter Donahue set up the modest blacksmith shop on Montgomery Street that came to be known as the first foundry in the West—Union Iron Works (UIW). When Irving M. Scott, at left, became UIW's general manager in 1865, the foundry was located at First and Mission Streets where the Transbay Transit Terminal stands today. Scott, a brilliant engineer, businessman, and politician, was almost selected as a Republican vice presidential candidate. (Courtesy Bancroft Library, UC Berkeley.)

Irving M Scott

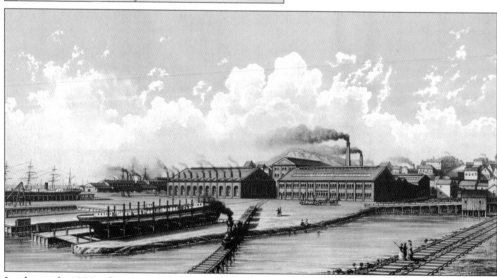

In the early 1880s, Scott toured shipyards on the East Coast and in Europe, and returned to San Francisco with the aim of expanding UIW's shipbuilding capabilities. In 1883, he built a new plant on 32 acres of filled land with deep-water frontage on the north side of Potrero Point. UIW was the most up-to-date iron works and shipyard of its day. (Courtesy Bancroft Library, UC Berkeley.)

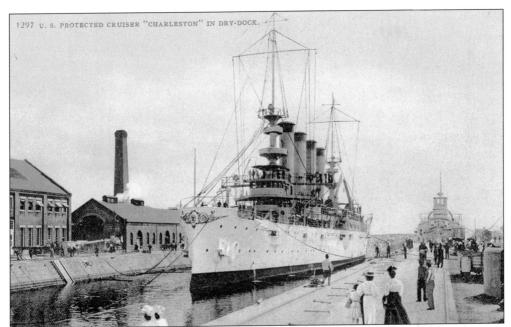

This is a postcard depicting the armored cruiser USS *Charleston* in dry dock at the Union Iron Works. In 1886, after strenuous politicking by Irving M. Scott, UIW received a government contract to build the armored cruiser *Charleston*, which was launched in July 1888. (Courtesy the late Herb Wasserman.)

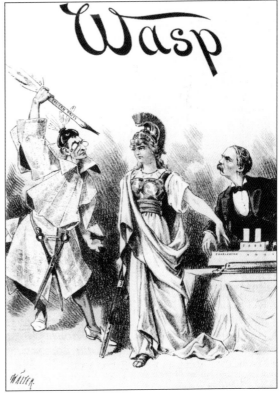

Also launched was "Eastern Jealousy of California's Success," depicted in a cartoon published in the September 21, 1889 edition of *The Illustrated Wasp*. A figure representing San Francisco defends Scott (his hand on a model of the *Charleston*) from charges of pork barrel and bribery hurled by the East Coast press made anxious by seeing defense contracts taken away from its shores. Scott promised his UIW workers that weapons contracts would "distribute again in the channels of trade what the government has gathered from you in the shape of revenue and taxes," and would be "the key to unlock the treasury."

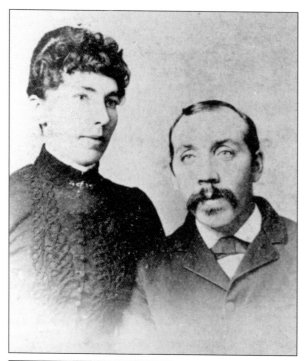

Irish-born James and Margaret Glover were perhaps typical of the working-class families who lived in Potrero in the late-19th and early 20th centuries. James worked at Union Iron Works (UIW), and as newlyweds in 1884 they lived on Irish Hill. As the family grew, they moved to the flats. The Glover children went to I. M. Scott School, St. Teresa's Church (then on Tennessee Street), and the nickelodeon on Kentucky and Nineteenth Street, where for 5¢ they could see the first silent movies. When old enough, two sons went to work at UIW, as did a grandson after it was known as Bethlehem Shipyards. Widowed in 1898, Margaret supported the family by taking in both roomers and washing, and later moved to Texas Street. (Courtesy Margaret Vetter.)

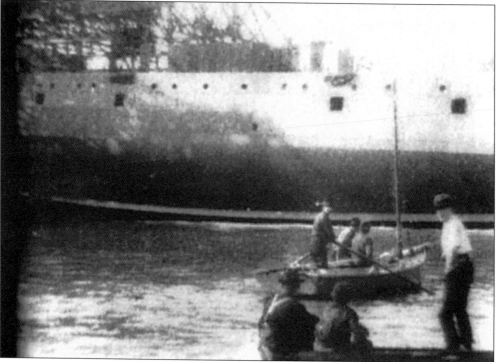

In 1898, Thomas Alva Edison filmed the launching of the *Chitose*, built for Japan at UIW, which was an event so exciting that over a thousand people showed up. One hundred doves were released, and spectators in rowboats were inspired to dive into the water to follow the ship on its maiden cruise into the bay. (Courtesy Library of Congress.)

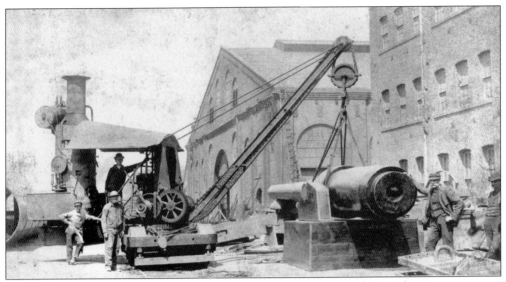

From the late 1880s until the end of World War II, Union Iron Works was the most important industry in the Potrero and perhaps on the entire West Coast. During its heyday, UIW employed many Hill residents, including a quarter to half of the residents living in nearby Dogpatch. (Courtesy San Francisco Maritime National Historic Park.)

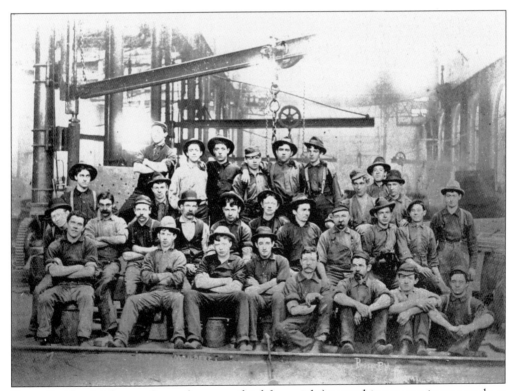

Oscar Smith of Arkansas Street (top row, third from right) wears his cap at a jaunty angle as he poses with other workers at UIW about 1900, shortly after serving in the Spanish-American War. (Courtesy Wifstrand family.)

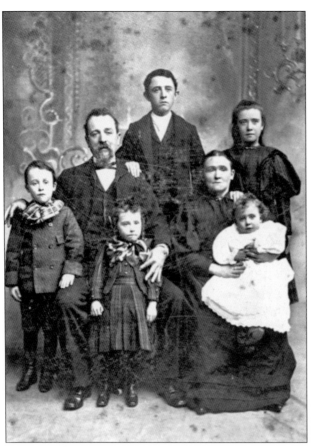

Scotland-born Daniel Law, shown in this 1897 portrait with his wife Mary and their five children, was a caulker and riveter at Union Iron Works. Two of Daniel and Mary's sons also worked at UIW: James (standing behind Daniel) and Harry (far left). (Courtesy Mary Law.)

The Laws lived at 1012 Tennessee Street in one of a row of Pelton cottages, so called because their design was based on a series of architectural plans for inexpensive workers' dwellings by John Cotter Pelton Jr. that were published in the *San Francisco Evening Bulletin* between 1880 and 1883. Thirteen Eastlake-style Pelton cottages survive in Dogpatch on Minnesota and Tennessee Streets, between Twentieth and Twenty-second Streets. Shown here is the Tennessee Street row today; the house on the far left is the old Law family home. (Photo by Peter Linenthal.)

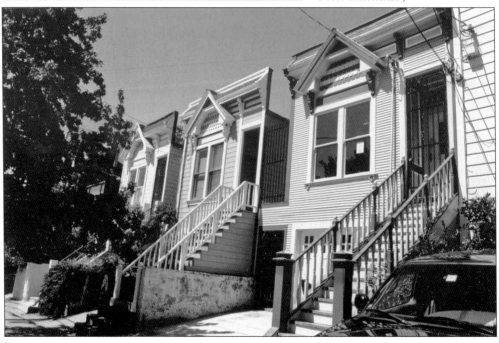

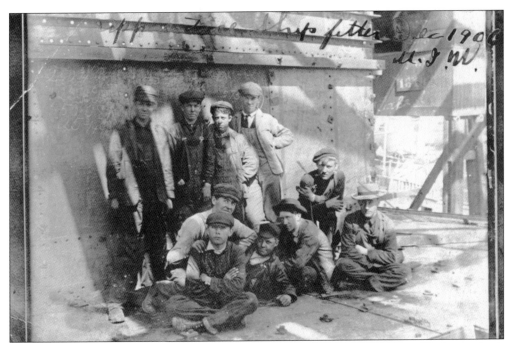

In the 1860s, Irving M. Scott developed an apprentice system at Union Iron Works in which boys signed on for four years, making $4 a week their first year, and $10 a week by the time they graduated. In the photograph above is Harry Law (back row, second from left) as a 14-year-old apprentice ship fitter at UIW in 1906. (Bethlehem Steel bought Union Iron Works in 1905, but the old name continued to be used for many years.)

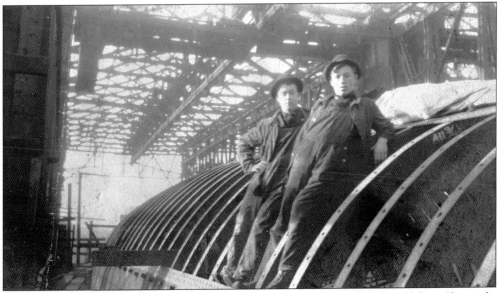

Harry (on the left, age 26) is working on a submarine at the Union Plant of Bethlehem Shipyards, Potrero plant, in 1918. (Courtesy Mary Law.)

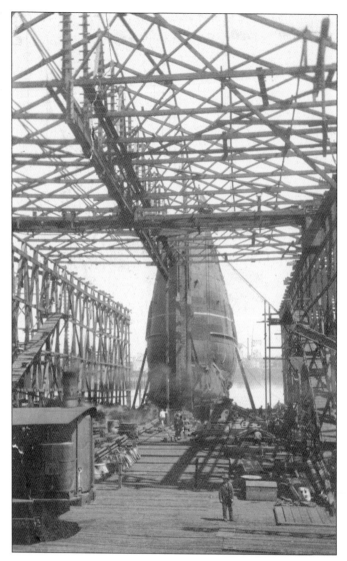

A huge gate for the Hunters Point dry dock nears completion at the Bethlehem Shipyards, Potrero plant, in 1918. The same year, Bethlehem's Alameda plant built the 12,000-ton *Invincible* in 24 days, setting a world record in shipbuilding. During the 19 months between the declaration of war on Germany (April 6, 1917) and the signing of the Armistice (November 11, 1918), Bethlehem built more of the largest torpedo boat destroyers (30) than all other private and government yards combined, launching eight on July 4, 1918. They also built all the submarines (20) completed in the country for war service. (Courtesy Mary Law.)

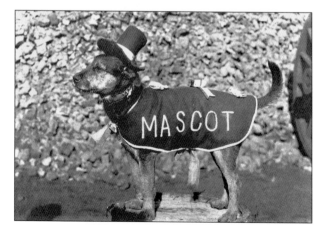

This is an image of the UIW mascot from the album of J. T. Scott, shipyard manager from 1895 to 1905. Scott was the nephew of Irving M. Scott. (Courtesy San Francisco Maritime National Historical Park.)

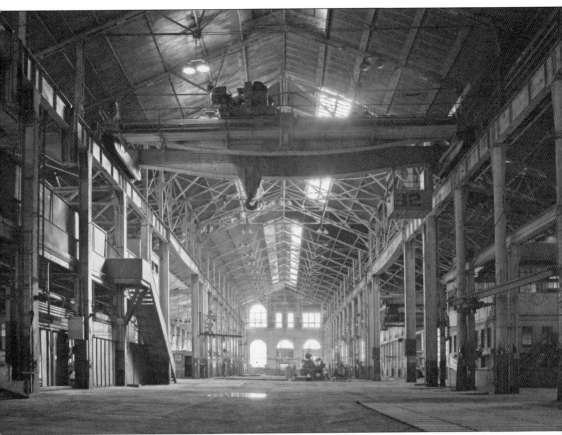

The machine shop was the centerpiece of Irving M. Scott's state-of-the-art shipbuilding and manufacturing facility. Skilled workers used the forges and large machine tools to make and repair the many thousands of metal parts needed for the large ships, mining, and industrial equipment produced there. The building was originally two brick structures separated by a railroad track and road. These structures were combined into one 450-foot-long building during World War I through the addition of a white concrete structure between them. The building's large arched metal door is tall enough to allow railroad cars and large equipment to pass through, and is an excellent example of an industrial building, with its cast iron columns, steel trusses, and gantry cranes. Early in 2004, the machine shop was closed after more than 120 years of service. Even though it had survived two major earthquakes, it was deemed seismically unsound. Hopes are high that it can be retrofitted and given a new use. For more information, go to www.pier70sf. org. (Photo by Ralph Wilson.)

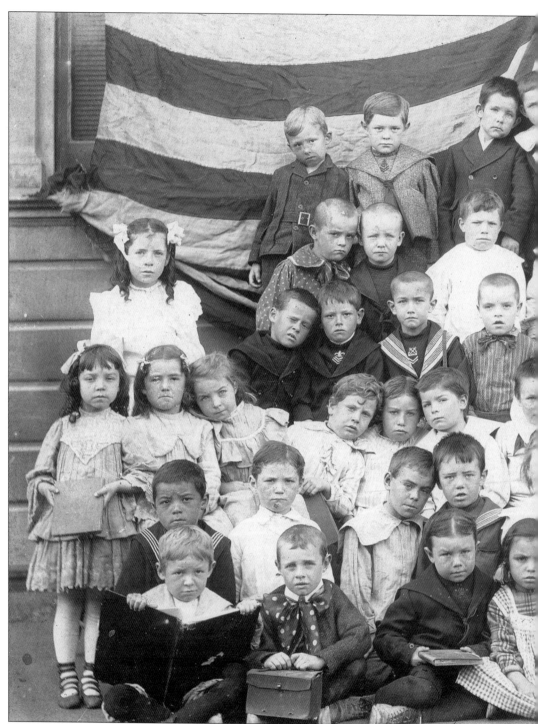

The first school on the Hill was the Potrero School, built in 1865 on the northeast corner of Kentucky (Third) and Napa (Twentieth) Streets. The school expanded in 1877, and moved to Minnesota Street between Napa and Sierra (Twenty-second) Streets. In 1895, an eight-room schoolhouse was built on the same site, but with its entrance at 1060 Tennessee Street,

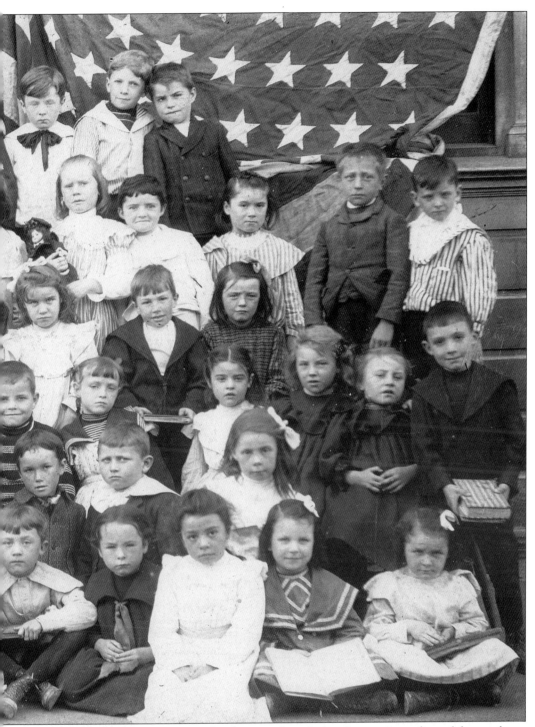

and renamed Irving M. Scott School to honor its benefactor, the superintendent of the nearby Union Iron Works. (That same year, the names of the Hill's east-west running streets, named for California's counties, were changed to numbers.) Young students of I. M. Scott School are shown here in an early 1900s photograph. (Courtesy Norris family.)

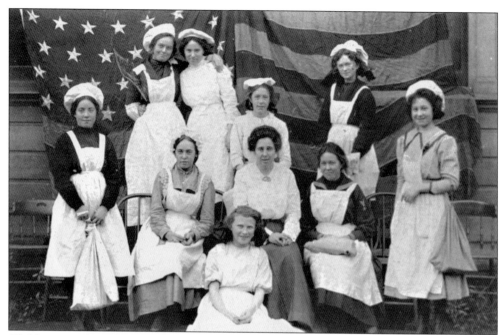

Children ages 6 to 16 attended I. M. Scott School, which emphasized practical trades and skills: cooking and homemaking for the girls (seen here is a 1912 cooking class), and manual skills for the boys. (Courtesy the late Ann McCarthy.)

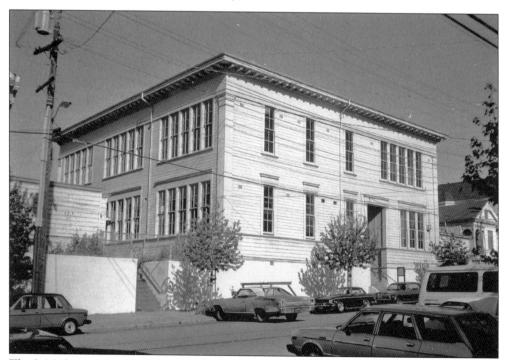

The I. M. Scott School building was declared a San Francisco Historic Landmark in 1985, and is the only public school individually listed in the National Register. The oldest school building in the city, it is now home to the Omega Boys Club. (Photo by Peter Linenthal.)

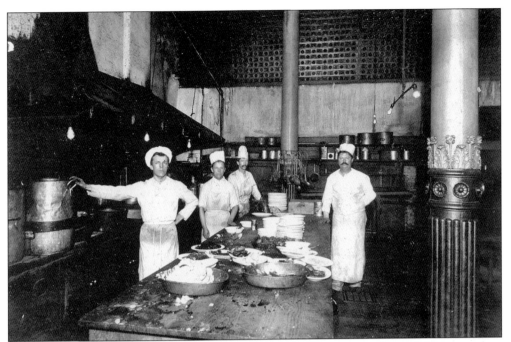

In 1904, this restaurant kitchen at Kentucky and Twentieth Streets no doubt fed many workers from nearby shipyards. The building was torn down in 1912 to make way for a police station, which is still standing at 2300 Third Street but no longer in use. (Courtesy Don Kambic.)

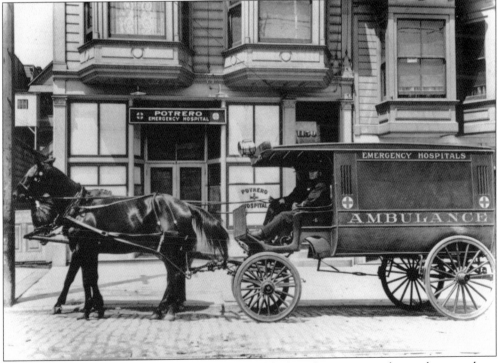

The Potrero Emergency Hospital was on the same block as the restaurant shown above, perhaps right next door. (Courtesy San Francisco History Center, San Francisco Public Library.)

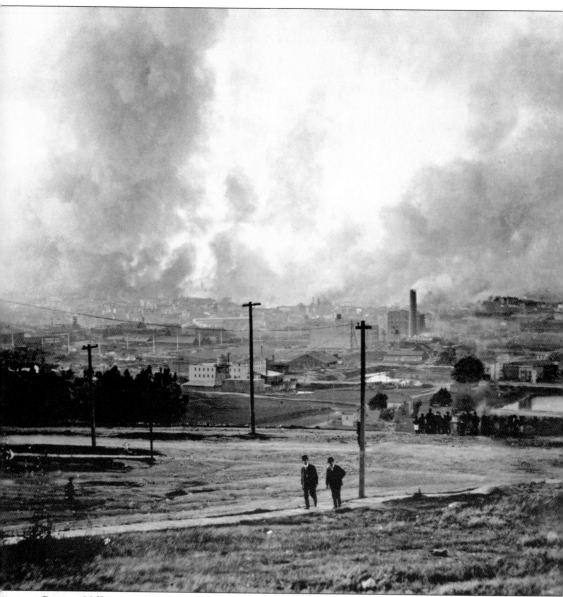

Potrero Hill escaped the most devastating effects of the April 18–23, 1906, earthquake and fire that destroyed three-quarters of the city. The Hill's foundation of serpentine withstood the shocks, and the firestorm, which created winds of more than 100 miles per hour, was extinguished along Howard, Division, and King Streets, never reaching the Hill. Edward Jones, chief engineer of the San Francisco Electric Company, managed to turn off valves at the Potrero Works on Kentucky (Third) Street, and "prevented the addition of fuel to the flames." Potrero Hill residents near

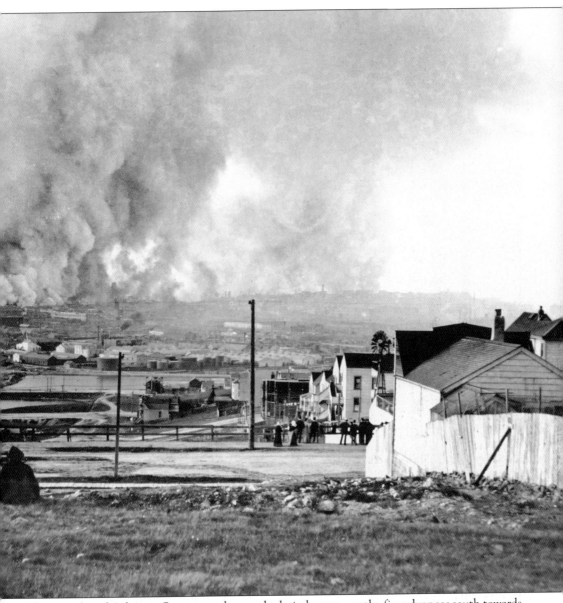

Nineteenth and Arkansas Streets watch—no doubt in horror—as the fire advances south towards them. The tall smokestack at left was part of the "crematory," a garbage-burning facility south of Market Street. Note the windmill at right that drove the pump of a well. This panorama is particularly interesting because it clearly shows several ponds along Sixteenth and Seventeenth Streets, remnants of Mission Bay. Old timers have mentioned them, but photographs of the ponds are rare. (Courtesy private collector.)

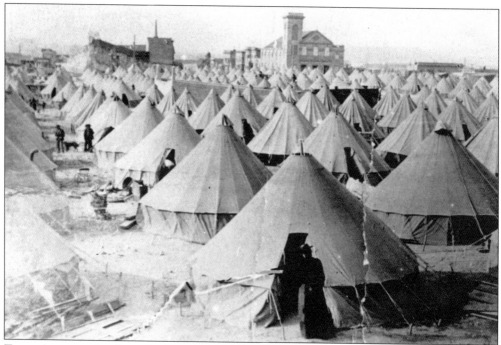

Tents, Army surplus from the Spanish-American War, were set up from Nineteenth Street to Twenty-second Street between Indiana and Kentucky (Third) Streets for San Franciscans made homeless by the earthquake and fire. This view is from about Indiana and Twenty-first Streets, looking north toward St. Teresa's on Tennessee Street. (Courtesy St. Teresa's Church.)

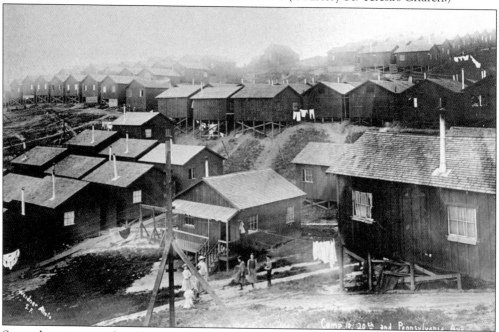

Somewhat more comfortable were the two-room houses (called shacks by the people who lived in them), built by the government in several San Francisco neighborhoods. Here is Camp No. 10 at Twentieth and Pennsylvania Streets. Several shacks remain on the Hill today.

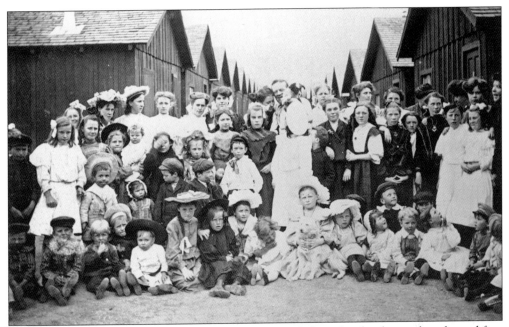

Ellie Baine was eight years old when her family was made homeless by the earthquake and fire. At first the family slept in an open field, then in a tent on Tennessee Street, and then moved to a government-built shack on Twentieth Street near Iowa Street. Ellie is in the middle of the front row with her pet dog. (Courtesy the late Ellie Baine.)

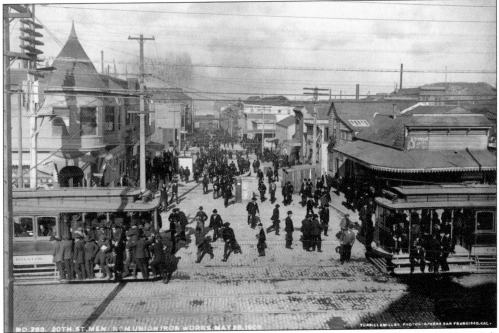

This view looks east on Napa (Twentieth) Street at Kentucky Street. This bustling scene, with UIW workers coming off a shift, shows a neighborhood still intact about six weeks after the disaster. Streetcars anticipate today's Third Street Light Rail. The building at left still stands. (Courtesy California Society of Pioneers.)

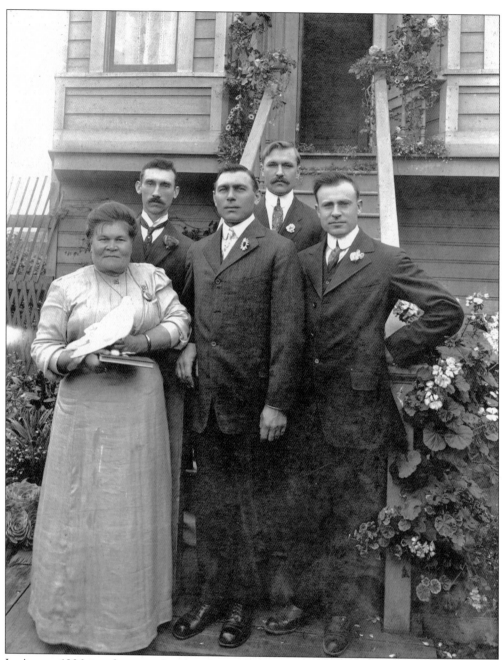

In August 1906, just four months after the earthquake and fire, a small band of Russian refugees were dumped by a surly drayman at Twentieth Street and Illinois near Union Iron Works, which ended a 27-month trek from their Russian village near the Turkish border. The new arrivals were called Molokans, "milk drinkers," because of their defiance of the official Russian Orthodox proscription of dairy foods on fasting days. Perhaps the prosperous-looking folk above were among them, but all that is known is what's written on the back of this and a similar photograph (both found at a flea market in the 1990s): "Russian people SF/off Mariposa out by Third St./House on Mississippi St." (Courtesy Suzanne Dumont.)

Fedor Ivanovich Buchneff, his wife Alena, and their five children were among the Molokans deposited at the base of the Hill who joined the tent and shack community of people made homeless by the earthquake and fire. Rebuilding the city afforded many opportunities for the newcomers as men and boys over 12 found jobs as stevedores, day laborers, ship builders, and construction workers; women could work in laundries and rag-recycling plants. Soon families were able to save enough money to buy houses or lots of their own. Most of the open space on the Hill was around the summit at Carolina and Twenty-Second, where by 1907 a Russian settlement began to emerge. Fedor Ivanovich conducted religious services at his home at 950 De Haro Street (the first house built by a Molokan on Potrero Hill) until the sect built its own church. This 1920 photograph shows newlyweds Fedor Jr. (Fred Bushneff), age 20, and Emma Loskutoff, age 17, dressed in the traditional clothing worn for church services. Fred is wearing a shirt called a roobashka, and Emma is donning a kasinka, a shawl head covering. (Courtesy George Bushneff.)

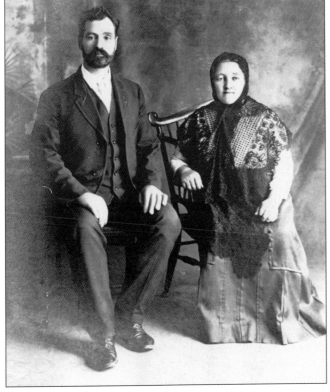

Another Molokan family that settled on the Hill following the earthquake and fire was the Fadeff family. Alex and Mary ("Masha") Fadeff arrived in San Francisco with six children and had seven more at the home they built in 1911 at 811 Rhode Island Street, now the home of their great-granddaughter, Joan King. (Courtesy Joan King.)

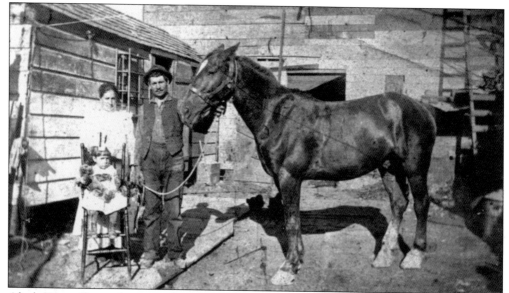

Aleck Karetoff was also a member of the original group of Russian Molokans who settled on the Hill. He married Emma Fadeff, the daughter of Alex and Masha, and raised a family at 877 Rhode Island Street. In 1914, their basic means of transportation was still a horse, kept in the barn with chickens and ducks just behind the house.

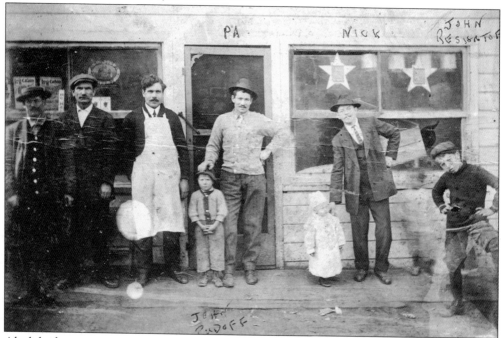

Aleck had a grocery store across the street from the family home where he sold meat, produce, and certainly the sunflower seeds (*semitchke*) popular with the Russian community. He kept track of customers' purchases during the week and would settle up their accounts on payday. During prohibition, he discreetly accommodated thirsty patrons in a back room. The grocery did so well that Aleck was able to retire at 35. He lived to be 99, and took his grandchildren to peace demonstrations well into his old age. (Courtesy Joan King.)

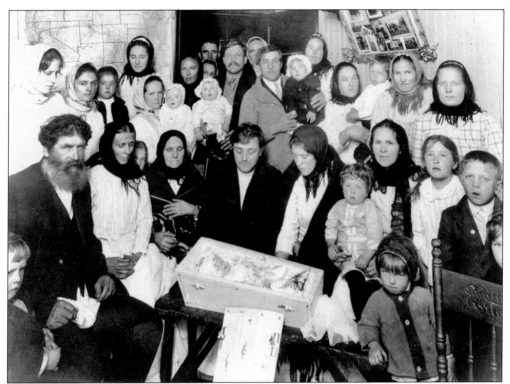

This is an image of the funeral of Nick and Mary Loskutoff's son in the early 1920s, probably at the family home at 1027 De Haro Street. Before building their church at 841 Carolina Street in 1932, the Molokans held services in a different member's home. After the church was built, funeral services often included carrying the casket from the church past the home of the deceased to the hearse. (Courtesy Rudometkin family.)

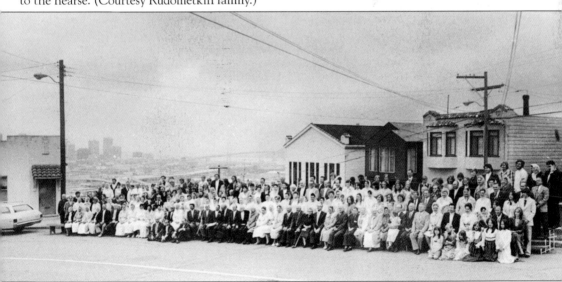

This image depicts the congregation of the First Russian Christian Molokan Church in 1976 on Southern Heights, just up the hill from church (the building in the center of the photograph.) (Photo by Bob Hayes.)

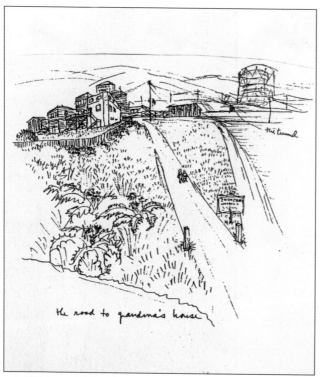

The Lym family, one of the first Chinese families in the neighborhood, lived at 1243-5 Minnesota from the early 1870s until 1953. This c. 1930 sketch, "The Road to Grandma's House, View from the Carbarn" (at Twenty-third and Third Street), is by Worley Wong, a Lym descendent and prominent Bay Area architect. (Courtesy Lym family.)

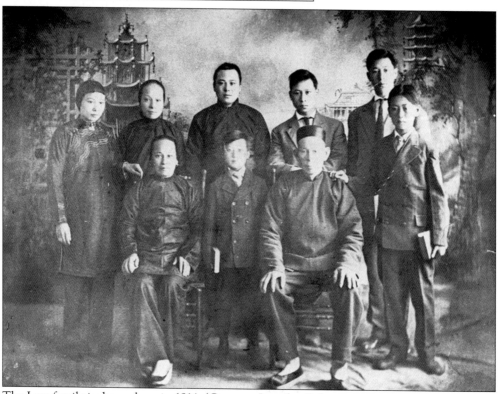

The Lym family is shown here in 1914. (Courtesy Lym family.)

Mrs. Wah F. Lym (Rose F. Joung) is shown here on her wedding day in December 1925 at 1243-1245 Minnesota with her mother-in-law, Mrs. Lim Lip Hong, known in the neighborhood as "China Mary." Rose Lym was born in Tonopah, Nevada, where her father was a labor broker for mining companies. (Courtesy Lym family.)

Arnold Genthe's photographs of pre-1906 Chinatown document a lost world. He titled this photograph "The Fish Peddler," although it really shows Robert Lym (standing in the wagon) and his brother Fook Sing (foreground, third from right) selling pig intestines, cow stomachs, and other animal parts salvaged from Butchertown, just south of Potrero Hill. (Courtesy Library of Congress.)

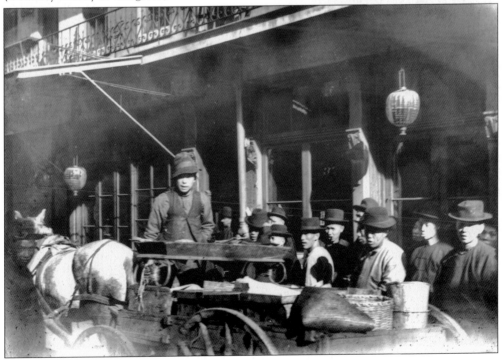

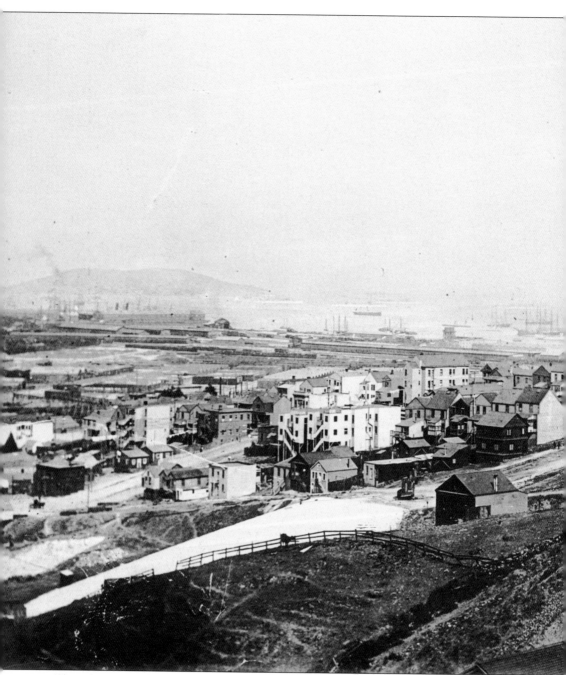

This 1908 panoramic view of Potrero Hill was taken from near Carolina Street on a slope just above Twentieth Street, looking northeast. The cows are standing at the intersection of Wisconsin and Twentieth Streets. The elegant hip-roofed house behind them to the right is standing today, although its facade is largely obscured by luxurious exotic plantings. It is the Charles Hawes house on 1745 Twentieth Street. The two houses with Dutch colonial gambrel roofs at right are on Connecticut Street; Eighteenth Street is at the far left, and Nineteenth Street is in the middle of the photograph. In the distance, the U.S. Navy's Great White Fleet is just visible. Sixteen

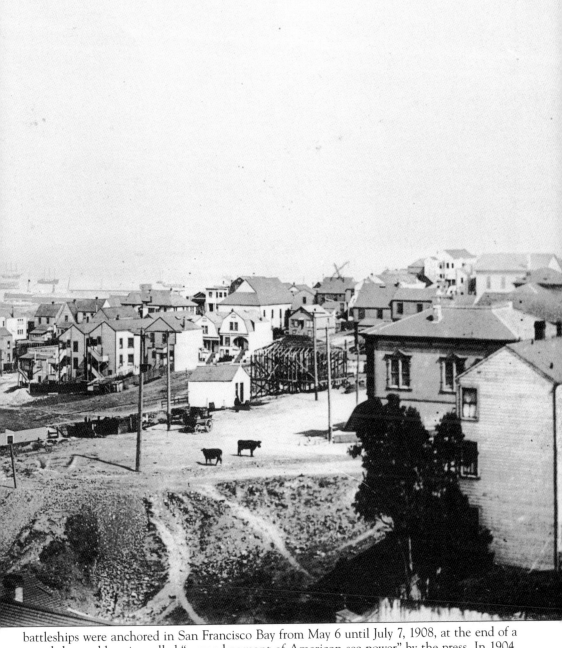

battleships were anchored in San Francisco Bay from May 6 until July 7, 1908, at the end of a round-the-world cruise called "a grand pageant of American sea power" by the press. In 1904, Pres. Theodore Roosevelt described the country as "the policeman of the western hemisphere." From that time until 1907, 11 new battleships were built for the U.S. Navy, many at Potrero Hill shipyards. These ships were the weapons of mass destruction of their day and the "big stick" behind Roosevelt's announcement that the United States would intervene in the affairs of any nation that threatened the country's interests. (Courtesy Marilyn Blaisdell.)

Slovenians settled south of Market prior to 1906, and sought refuge on Potrero Hill after the earthquake and fire. Martin and Anna Judnich established Judnich's Bar and Boardinghouse in 1912 at 590 San Bruno and Eighteenth Streets, which became home to many Slovenian immigrants. In the late 1940s, the building was moved to make room for the James Lick Freeway, Highway 101. (Courtesy Virginia Sustarich.)

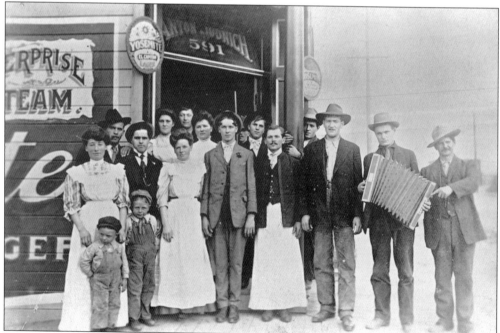

This is a 1908 photograph of Anton Judnich's Saloon on 591 Vermont and Eighteenth Streets. Anton is in a white apron, his wife Ursula is at far left with their two sons Tony and Frank. (Courtesy Don Kambic.)

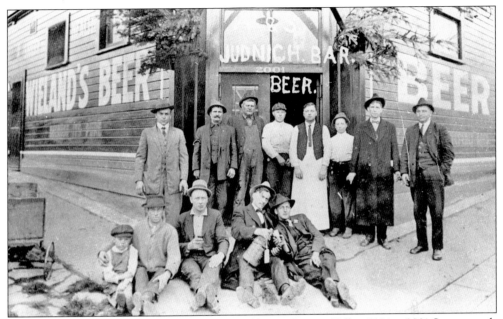

Anton Judnich opened the first Slovenian-owned bar on Potrero Hill in 1904 at 2001 Seventeenth Street at Kansas Street. In this 1912 photograph, Anton, wearing a vest over his apron, stands in the doorway flanked by sons Tony (Anton Jr.) and Frank. In the 1930s, Tony and another son, Henry, took over the bar and operated it until 1962. Today it is the Garden of Tranquility, a Chinese restaurant. (Courtesy Don Kambic.)

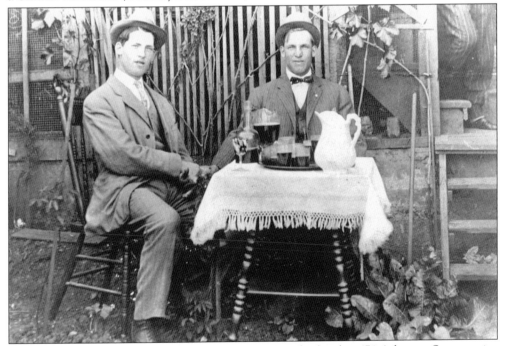

Brothers John and Matt Babic, Slovenian immigrants who lived at 474 Arkansas Street, enjoy locally brewed beer in the grape arbor and picnic area behind the popular Kansas Street bar. (Courtesy Don Kambic.)

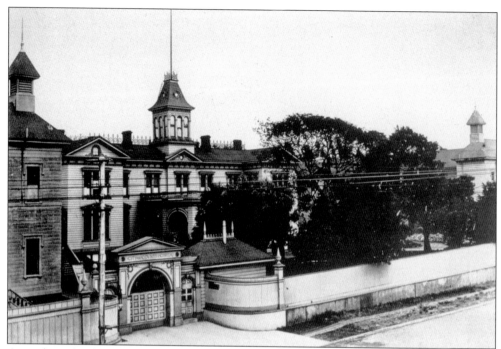

A pavilion-plan hospital with wards connected by covered walkways was built at 1001 Potrero Avenue in 1872. (Courtesy Bancroft Library, UC Berkeley.)

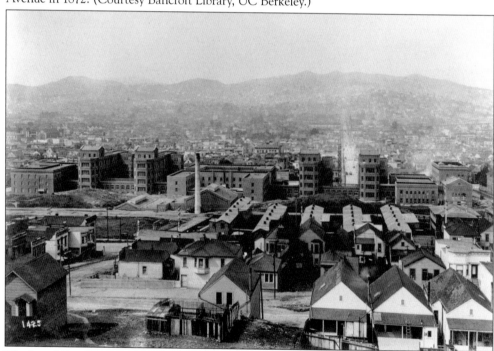

The "new" San Francisco General Hospital is seen here in 1913, from Rhode Island and Twenty-second Streets looking west toward the Mission District. The three houses at lower right are 1041–1053 Kansas Street. (Courtesy San Francisco History Center, San Francisco Public Library.)

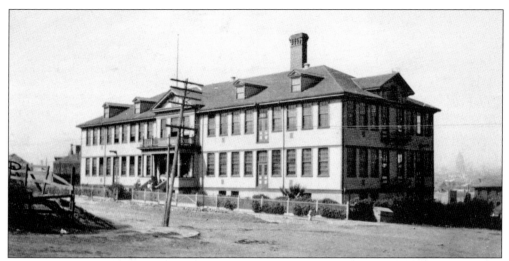

In 1895, the California School of Mechanical Arts, endowed by reclusive millionaire James Lick, opened in a brick building on a city block bounded by Fifteenth, Sixteenth, Utah, and San Bruno Streets. In 1901, the Wilmerding School of Industrial Arts (seen here about 1909—note the earthquake-damaged city hall dome in the background to the right) opened across the street between Sixteenth and Seventeenth Streets. Lux School of Industrial Training for Women opened at Seventeenth and Hampshire Streets in 1912. The three schools shared administrations. Today, UPS occupies the site of the old Wilmerding School, which is now Lick-Wilmerding High School on Ocean Avenue. The Lux building still stands on a small bluff behind a gas station on Potrero Avenue. (Courtesy Glenn Koch.)

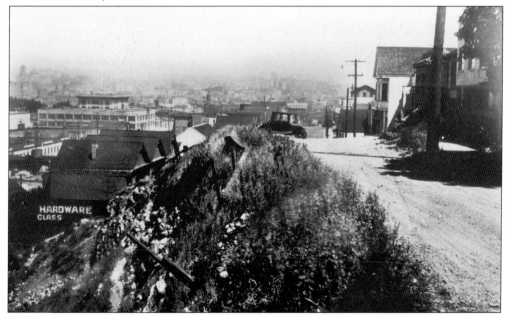

This is the western slope of Potrero Hill looking north sometime after 1912. A warehouse at the far left is at Seventeenth Street and Potrero Avenue, and behind it is the Lux School. Behind a utility pole on the right the roof and top floor windows of the Wilmerding School can be seen. The car seems to be on an unpaved section of Utah Street. (Courtesy San Francisco Department of Public Works.)

John and Sarah Warnock are seen here in 1910, together with children Fred and Irene, in the yard of their home at 1020 Minnesota. John came to San Francisco as a seaman. He became a station engineer for San Francisco Gas and Electric Company at Humboldt and Twenty-second Street. With an inheritance from his uncle, John built three houses on Twentieth Street: 1409 (built for Irene), 1415, and 1419. (Courtesy Robert Warnock.)

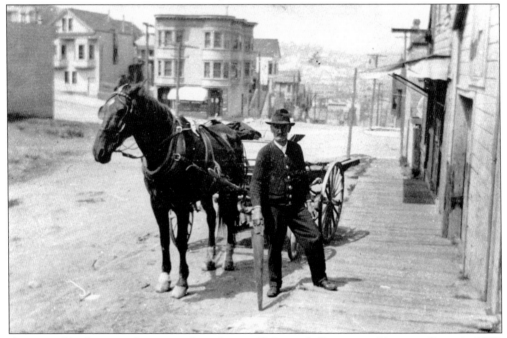

A man and his horse-and-cart pose for a shot on Eighteenth Street near Vermont Street in 1912. Anton Judnich's Vermont Street saloon was down the wooden sidewalk on the corner. Highway 101 is now one block west of this intersection.

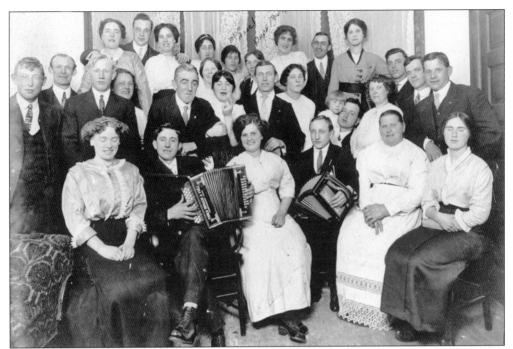

Festive gatherings in the early 1900s were not complete without accordions. Here the Monte Christo Social Club celebrates with two of them. Formed around 1905, the club provided the Hill's Italian residents a place to hold dinners and dances, and to indulge in the popular Italian sport of bocce ball. The club exists today, and hosts regular dinners at 136 Missouri Street. (Courtesy Don Kambic.)

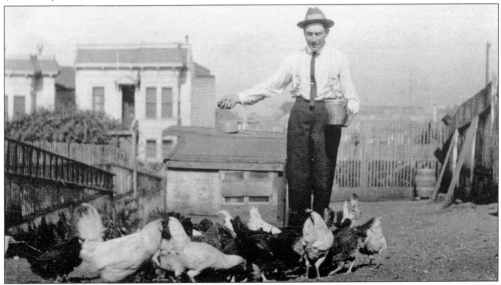

Oscar Smith feeds his chickens outside the family home on 612 Arkansas Street between Twentieth and Twenty-second Streets in 1915. Oscar's father acquired the property through "squatter's rights," as many people had in the 1860s. A few chicken keepers, mostly old timers, remain on the Hill today, but their birds are confined to backyards—unseen but not unheard. (Courtesy Wifstrand family.)

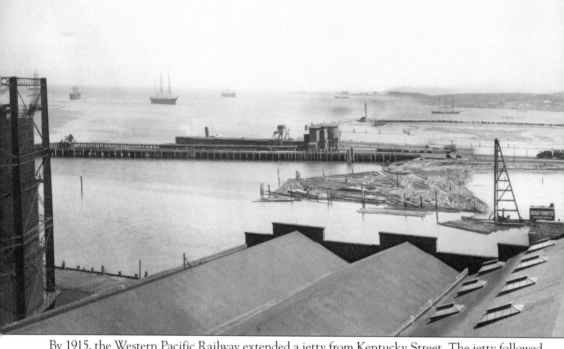

By 1915, the Western Pacific Railway extended a jetty from Kentucky Street. The jetty followed the same route as a wharf—shown on an 1869 U.S. Coastal Service map—that extended eastward into Islais Creek Cove from the vicinity of Twenty-fifth Street. Freight moved between train and ship, making a trip by rail around the bay unnecessary. In 1931, a Western Pacific ferry slip was built at Twenty-fifth and Delaware Streets.

This view looks south on Illinois Street at Twentieth Street from Union Iron Works, whose shop buildings are at the far left. In the distance, a section of Irish Hill remains, though by this time most workers had moved on to Potrero Hill and the Mission District. A companion photograph is on the facing page. (Courtesy San Francisco Maritime National Historic Park.)

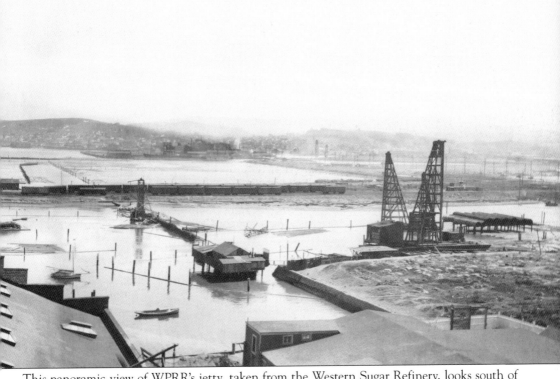

This panoramic view of WPRR's jetty, taken from the Western Sugar Refinery, looks south of the mouth of Islais Creek Cove toward the Bayview Hunters Point District. Long Bridge, south of Potrero Hill, is to the right. Virtually the entire bay seen here has been filled, adding to the Bayview district. Much of the fill was rock, blasted and hauled from Potrero Hill. (Courtesy Dave Margulius.)

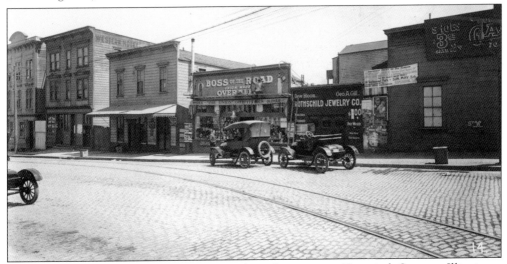

The roofs of these hotels, clothing stores, and jewelry stores on Twentieth Street at Illinois are just visible in the photograph on the opposite page. A sign announces a tug-of-war between teams from the UIW and Moore Scott at Shellmound Park. (Courtesy San Francisco Maritime National Historic Park.)

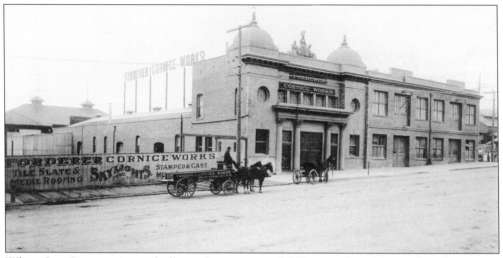

When San Francisco's city hall was being repaired following the 1989 earthquake, a time capsule was discovered. It dated back to the building's construction following the earthquake and fire of 1906. Among other things, the capsule contained business cards of Forderer Cornice Works. Forderer, founded in 1875, moved to Potrero Avenue at Sixteenth Street in 1906. The company, in Hayward since 1999, still owns the Potrero Avenue property where this building stands.

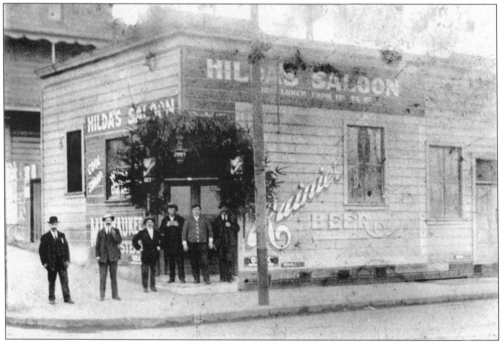

Potrero Hill abounded with watering holes in the early 20th century. Hilda's Saloon, built by the Salvotti family in 1907, was perhaps the most watery, as its site at Seventeenth and Connecticut Streets was on the original shoreline of Mission Bay. The basement, where Hilda Salvotti made the wine to accompany her 25¢, four-course meals, was subject to flooding and remains so today, to which the proprietors of Connecticut Yankee, a 21st-century watering hole, will attest. (Courtesy Salvotti family.)

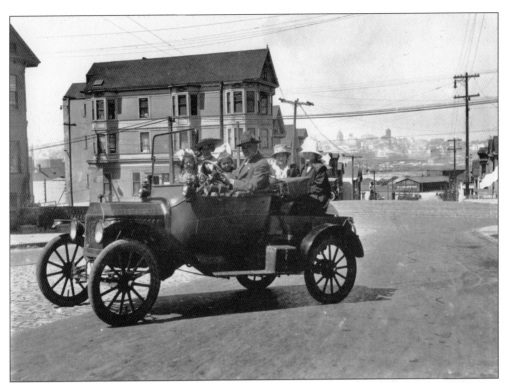

The Bertich family of 327 Missouri Street had one of the first cars in the neighborhood, seen here in 1917 at Missouri and Eighteenth Streets. The family used it to take trips to Sausalito, Oakland, and Neptune Beach on Alameda by car ferry, and to Cloverdale, Ukiah, and Skaggs Hot Springs. "Everyone who could afford it would get out of town on the weekends," recalled daughter Virginia Bertich Carlton. (Courtesy Carlton family.)

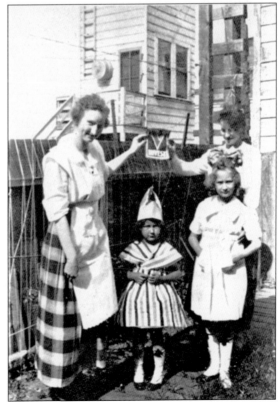

Virginia Bertich, dressed as Liberty in 1918, publicizes the sale of bonds to finance World War I. Over one-fifth of U.S. citizens bought bonds, many beginning to save money for the first time in their lives. (Courtesy Carlton family.)

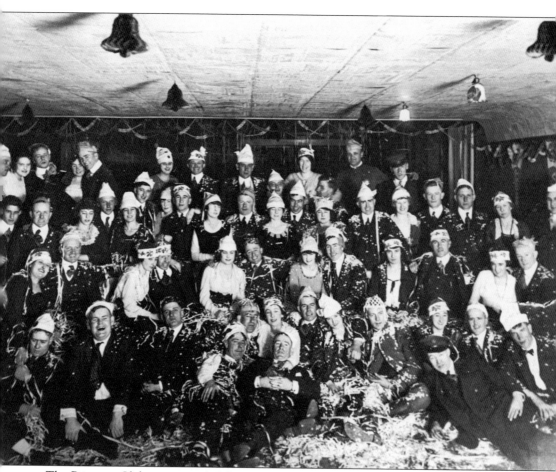

The Primrose Club was a social club on Iowa Street, where the 280 Freeway now stands. Many of its members worked for Bethlehem Steel, at both its Potrero and Alameda plants. Harry Law, age 27 and president of the club, reclines at front with his hands clasped. One of the few members with a car, it was up to Harry to rush party-goers late at night to catch the last ferry to Alameda. In September 1919, the club held a "Welcome Home Banquet in Honor of Their Returned Brothers from France." Here the club is celebrating New Year's Eve 1919, perhaps with a bit more bubbly than usual by the looks of it. Just two weeks later, the 18th amendment to the Constitution, prohibiting the manufacture, sale, and transportation of alcoholic beverages, became effective.

Three

MODERN TIMES

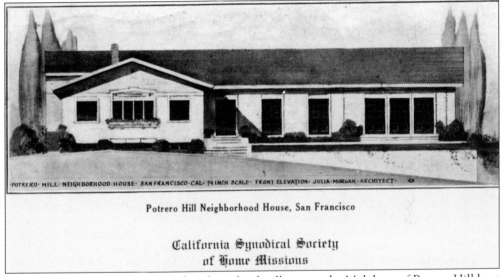

Potrero Hill Neighborhood House, San Francisco

With memories of persecution in their homeland still strong, the Molokans of Potrero Hill kept much to themselves. After one of them was injured in an accident at Union Iron Works, Dr. William Parker, lawyer and pastor of the Olivet Presbyterian Church on Missouri Street, helped him get assistance from his employer. This event broke the ice, and the Russian community became open to the outreach efforts of the church, which included Sunday school classes, a choir for children, and English and citizenship classes for adults. By 1920, the small rented space in which the activities were held was no longer adequate, and the California Synodical Society of Home Missions acquired property on De Haro Street north of Twenty-second Street with the intent of building a community center. The Potrero Hill Neighborhood House, designed by architect Julia Morgan who later became famous for her work on Hearst Castle, opened in 1922. Amenities at the Nabe, as it came to be known, included a spacious lobby with a fireplace, an assembly hall, clubrooms, a kindergarten room, and a gymnasium. An article in a 1925 issue of the *San Francisco Chronicle* described the early Nabe: "sunlight streams through broad windows, silhouetting bowed, heavily shawled heads . . . through the doors, heavy-eyed Russian women pass, sweeping broods of children before them." (Courtesy Glenn Koch.)

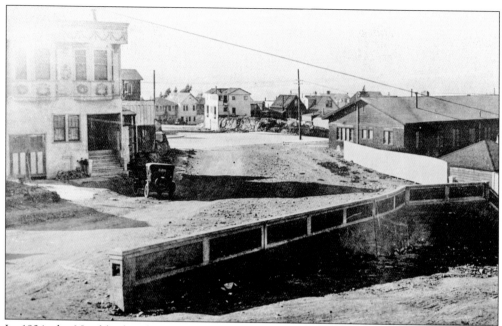

In 1924, the Neighborhood House was moved 90 feet north of its original location in order to allow construction of a diagonal street called Southern Heights Avenue. In 1930, the kindergarten building, also designed by Julia Morgan, was built on Carolina Street on a lot behind the Nabe. (Courtesy San Francisco Department of Public Works.)

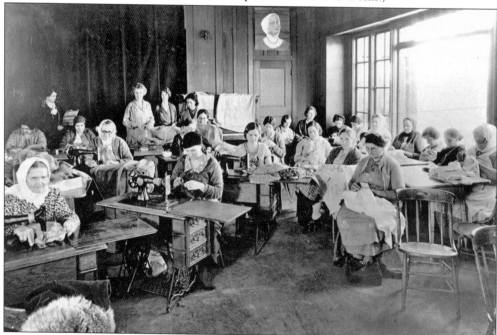

During the Great Depression, adult education programs became part of Pres. Franklin D. Roosevelt's New Deal. In 1935, Mrs. Anderson (standing at left) teaches an Emergency Education Program class in sewing to a largely Russian group at the Potrero Hill Neighborhood House. (Courtesy Rudometkin family.)

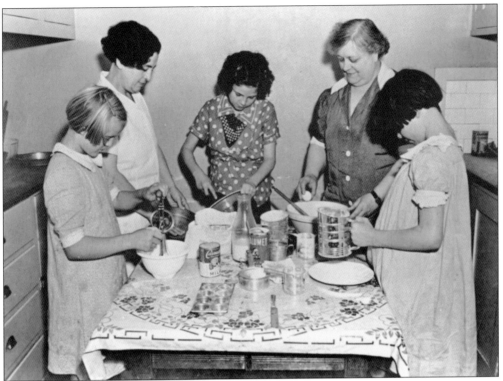

Shown here is a children's cooking class at the Neighborhood House in 1935. (Courtesy Rudometkin family.)

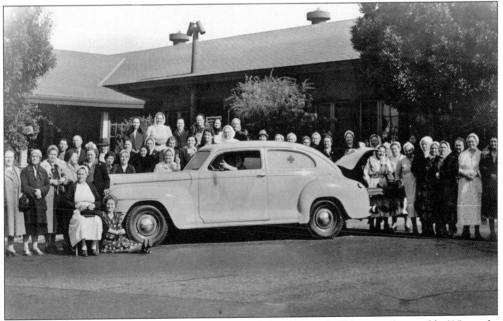

During World War II, the Potrero Hill Mothers Club sold *borscht* ($1 a quart), *peroshki* (25¢ each, five for $1), and *lapsha* (noodles) to raise money for the war effort. It was enough to buy this ambulance, seen here in front of the Neighborhood House. (Courtesy Rudometkin family.)

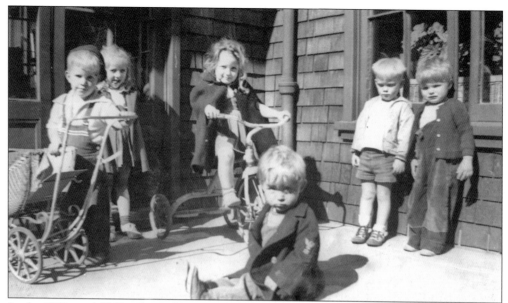

In the 1940s and 1950s, the Golden Gate Kindergarten Association ran a school at the Nabe. Innovative director Rhoda Kellog made rich art experiences available; research found a shared artistic development in children of all cultures. This 1940 image shows some of the Nabe kindergartners. (Courtesy Agnes Pritchard.)

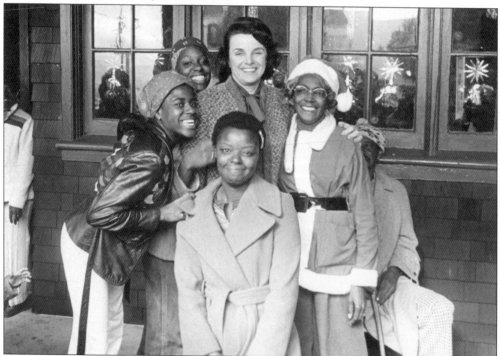

Enola D. Maxwell (right) was lay minister at the Olivet Presbyterian Church on Missouri and Nineteenth Streets from 1968 to 1971, and executive director of the Neighborhood House from 1971 until her death in 2003. Here, dressed as Santa, she greets Mayor Dianne Feinstein on a 1981 visit. (Photo by Bob Hayes.)

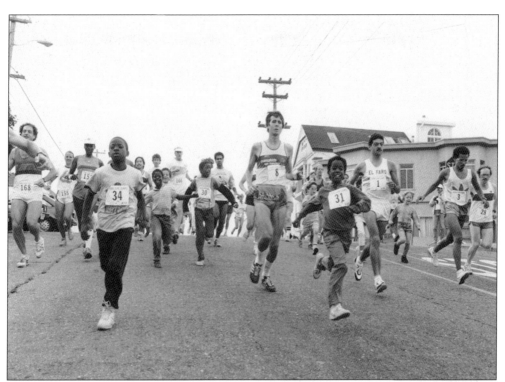

During the 1980s and 1990s, neighborhood merchants held a Scenic Scamper to benefit the Nabe. The 1987 Scamper attracted runners from all over the Bay Area, and even one from the state of Georgia. For 20 years, the Nabe housed the Julian Theater, which produced avant-garde plays under the direction of Richard Reineccius. It continues to offer a great variety of services to a changing community, and sponsors an annual street festival, a flea market, and other events. (Photo by Lester Zeidman.)

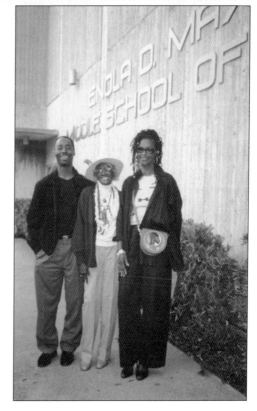

Potrero Hill's middle school on De Haro Street was officially renamed the Enola D. Maxwell Middle School of the Arts in 2001. It was built in 1971, on the site of the public housing project where Maxwell lived in the early 1950s. Maxwell is shown here with grandson Edward Hatter (who succeeded Maxwell as director of the Nabe in 2003) and daughter Barbara Dundy. Another daughter, Sophie Maxwell, was elected to the San Francisco Board of Supervisors in 2000 and represents the district that includes Potrero Hill. (Photo by Ruth Passen.)

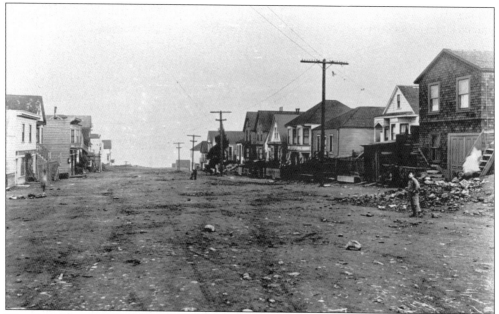

The San Francisco Department of Public Works took many before-and-after photographs, documenting its street-grading and paving projects. Here is unpaved Rhode Island Street in the 1920s; Chiotra's Grocery is the second building from the left.

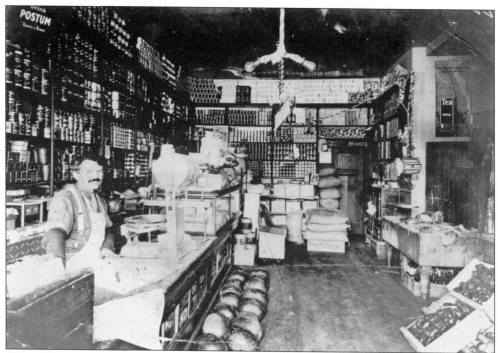

Chris Chiotras, a native of Greece, is shown in his grocery store at 858 Rhode Island Street around 1925. His son Pete took over the store in 1945, and his daughter Christina ran it until 1993. Under new ownership, but still bearing the Chiotras name, the store continues to serve residents at the very top of the Hill. (Courtesy Chiotras family.)

William Popin and his granddaughter Carole Sue Popoff are shown here in front of his grocery store, Popin's Hilltop Market, at 890 Carolina Street around 1946. Mr. Popin owned the store from 1925 until the mid-1950s when he turned it over to a family member. Since then it has had several incarnations—it's been home to a rare book dealer and to the Balloon Lady's family among others—and today is the studio of a furniture designer. (Courtesy Michael J. Popoff.)

This 1922 image shows Elvira Bonfiglio and her children Lou and Lena. The children were born at 303 Pennsylvania Street in a refugee shack built for survivors of the 1906 earthquake and fire. The family moved to 1512 Twentieth Street, where they built a bridge to a roof garden on an adjacent barn. (Courtesy Bonfiglio family.)

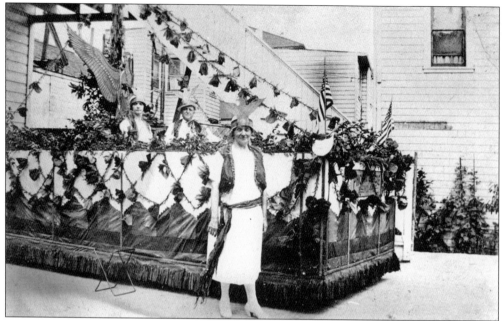

Hilda and Giovanni Salvotti started Hilda's Saloon (now Connecticut Yankee) at 100 Connecticut Street in 1907. After their divorce, Hilda ran it by herself. Here she is in 1917 with a float she made for the Druids Lodge. Hilda won three prizes at the lodge for her dancing. (Courtesy Salvotti family.)

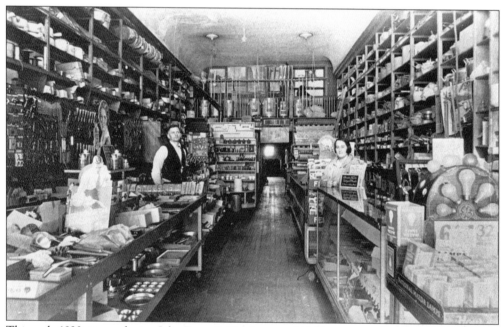

This early 1920s image depicts John Ferrari's Hardware at 344 Connecticut Street. In 1963, lifetime Hill resident Bert Kloehn took over the space for his Strand Appliances, which previously had several Hill locations, including where Chez Papa and Ford Realty are now. Today Strand is run by Bert's daughter Judie Lopez. (Courtesy Kloehn family.)

Mr. and Mrs. Troest ran this well-stocked store at 1310 Eighteenth Street (now Potrero Coin Laundry) in the 1940s. (Courtesy Milton Newman.)

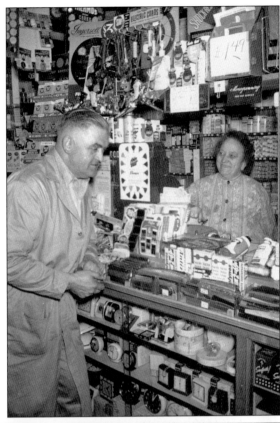

John Kambic was co-owner of Frank and John's Place, a bar and restaurant at 501 Potrero Avenue, where he's shown in 1932 holding his granddaughter Betty Ann; his partner Frank Doherty is on the right. Mr. Kambic was also a house builder and house mover. He built many homes on Potrero Hill and moved many others when the James Lick Freeway was under construction in the late 1940s. The bar was also moved, to 491 Potrero Avenue, where it is still a bar but called Sadie's Flying Elephant. (Courtesy Don Kambic.)

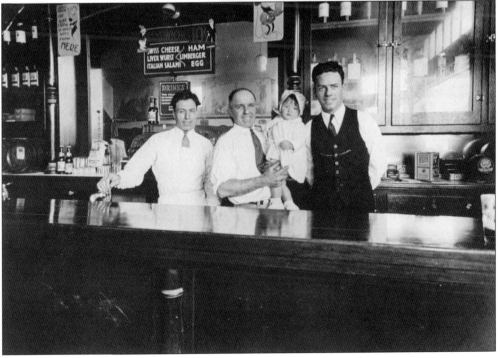

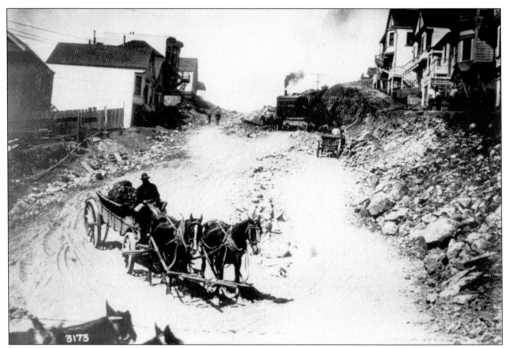

Many Potrero Hill streets remained unpaved well into the 20th century—the 1100 block of Tennessee Street was finally paved in 1980! The two photographs on this page show street grading on Carolina Street. This view looks north near Twenty-second Street in 1916.

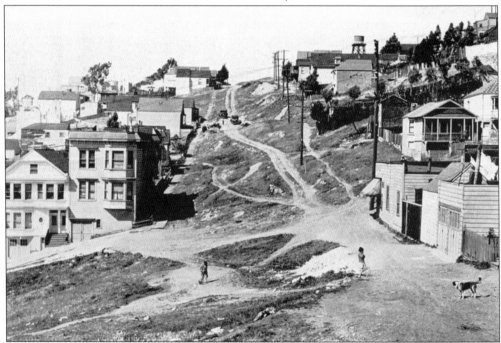

This image looks north from Twenty-third Street on April 2, 1931, just before the median strip was built. There is still a water tank at the top of Twenty-second Street. (Courtesy San Francisco Department of Public Works.)

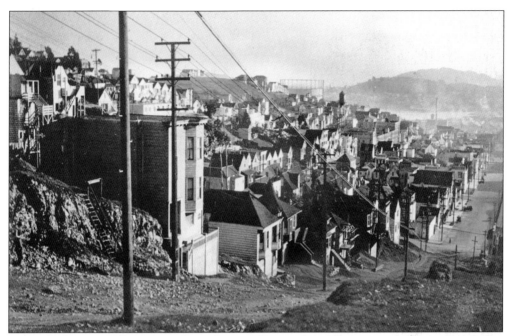

A stretch of Potrero Hill's Vermont Street between Twentieth and Twenty-second Streets (paralleling McKinley Square) rivals Lombard Street as San Francisco's crookedest. Vermont Street has only seven curves compared to Lombard's eight, but they are much tighter. A 1927 view south from McKinley Square shows unpaved "Vermont Street Straight." (Courtesy San Francisco Department of Public Works.)

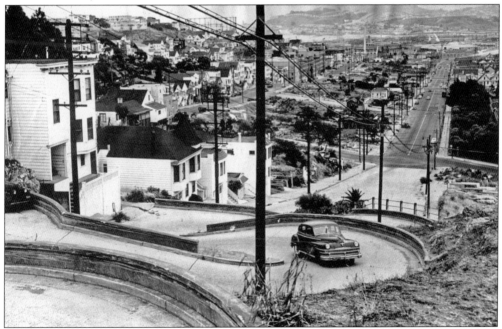

This is a 1940s view from McKinley Square. Landscaping along the curves was not undertaken until the 1960s. Today, the crooked stretch is one way—the other way. (Courtesy San Francisco History Center, San Francisco Public Library.)

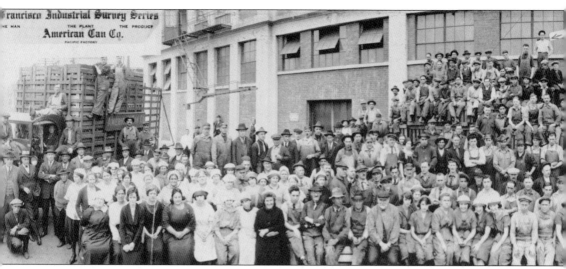

The American Can Company began in 1902 through the consolidation of 60 tin companies. It became known as Canco in 1915. By the early 1930s, their plant on Third Street between Twenty-second and Twenty-third Streets was considered the largest can plant in the world. Many employees lived on Potrero Hill; this company portrait was taken in 1921. The Canco Team was one

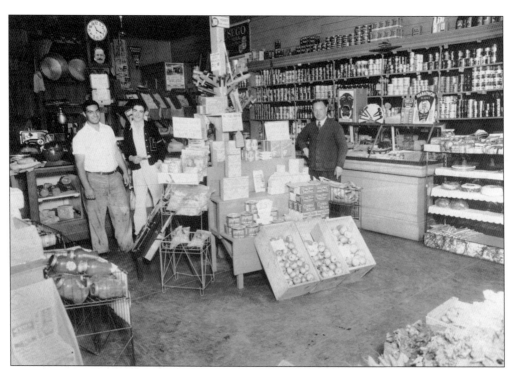

Phillip De Rosa came from Sicily in 1915. He was the proprietor of De Rosa's Grocery at 1701 Twentieth Street, seen here in 1933. Note the spigots for winemaking on the central column. Back in those halcyon days, you could call in a grocery order and have it delivered to your door. The store closed in the late 1980s. It is now Michael-Gary & Company, a hair salon. (Courtesy De Rosa family.)

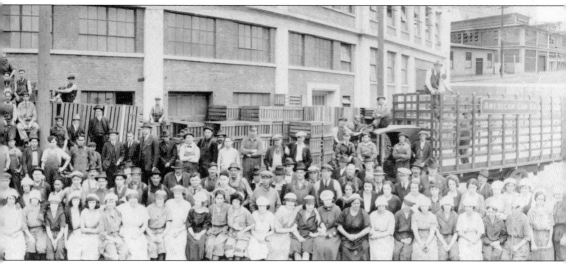

of a dozen San Francisco semi-pro baseball teams sponsored by local companies in the Industrial League. The unofficial headquarters was Kaneally's Pool Room near the shipyards in China Basin. Today, the Can Company building is home to many small businesses and artist studios, including graduate studios of the San Francisco Art Institute. (Courtesy Tommy Eagan.)

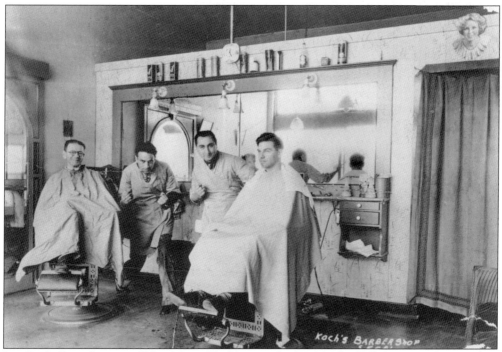

Joe Cochellato (known all his life as Koch) was a barber on the Hill for over 40 years, first at 317 Connecticut Street (now Delirious Shoes), then 1627 Twentieth Street, and finally at 1411 Eighteenth Street (now Bell & Trunk Flowers). He lived at 337 Missouri Street, and retired in the 1970s.

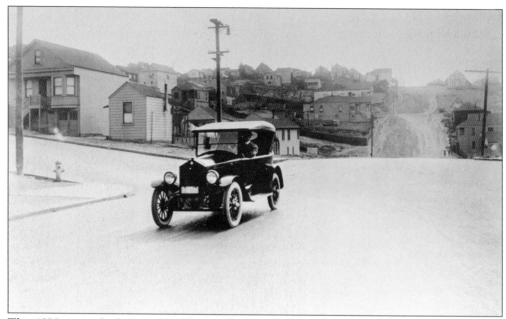

This 1920s image looks west from Twentieth Street at Wisconsin Street.

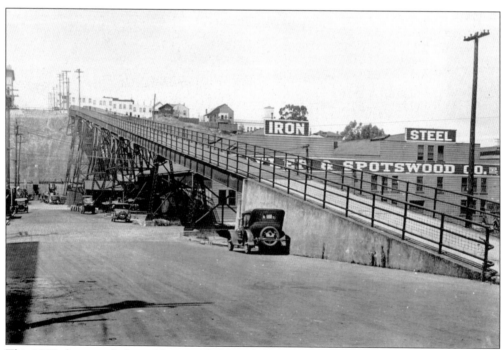

This 1927 photograph shows Nineteenth Street between Pennsylvania Street and Minnesota as a pedestrians-only bridge. St. Teresa's Church was one block east of this spot until it was moved up the hill in 1924. (Courtesy San Francisco Department of Public Works.)

St. Teresa's Church was founded in 1880 with parish boundaries of Carolina Street to the west, Army Street to the south, the bay to the east, and Channel Street to the north. Before the church had its own building, Sunday masses were celebrated in the dining room of the Hotel Breslan at Twenty-second and Georgia Streets, in a school on Kentucky and Twentieth Streets, and in a former hair mattress factory. Finally, in 1892, a church was built on the northeast corner of Nineteenth and Tennessee Streets. (Courtesy St. Teresa's Church.)

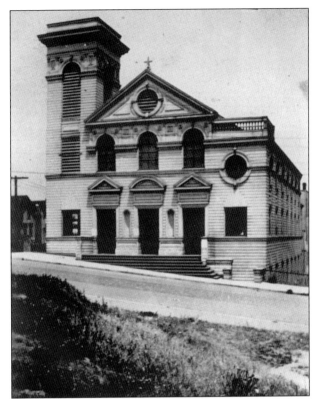

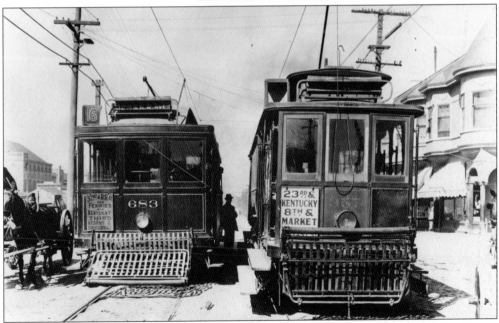

Shown here are cars of Market Street Railway's No. 16 line near the Kentucky Street Car House, known as the Kentucky Barn, between Twenty-third and Twenty-fourth Streets. St. Teresa's is just visible at far left. This photograph was taken sometime before 1915 when Kentucky Street was renamed Third Street.

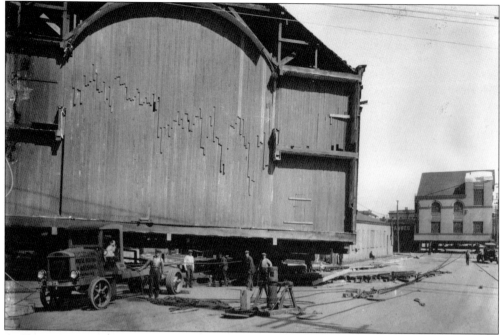

As Tennessee Street became increasingly industrial, and more and more parishioners lived higher on the Hill, the church building was moved in 1924 to Connecticut and Nineteenth Streets. D. J. & T. Sullivan House Moving and Raising Company cut the church in two and pulled each section up the Twentieth Street viaduct with ropes. These photographs were discovered in a dumpster in 1995. (Courtesy Marilyn Blaisdell.)

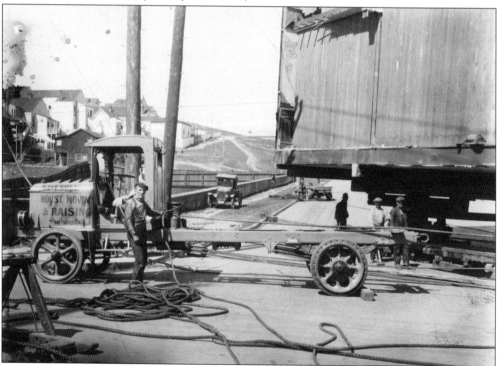

Mary Fitzgerald and Bob Delaney, both seven years old and members of St. Teresa's parish, pose for their first communion portrait in the backyard of 345 Missouri Street in 1924. (Courtesy Carroll and Lyons families.)

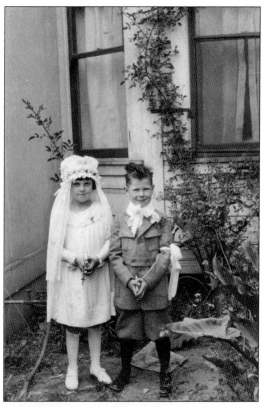

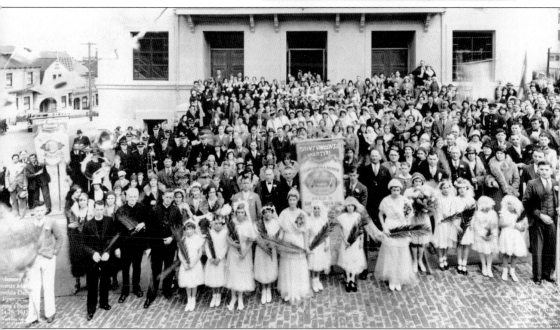

Participants in the 1932 Feast Day of St. Vincenza, patron saint of Blato (an island off Yugoslavia), pose in front of St. Teresa's on Nineteenth Street at Connecticut Street. The procession wound through the neighborhood and featured a marching band. (Courtesy Berelich family.)

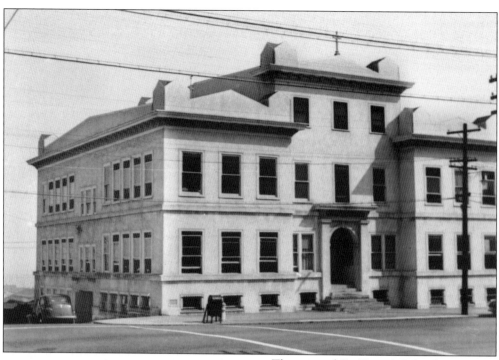

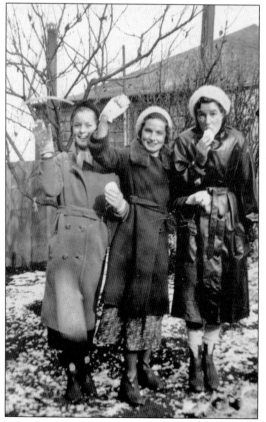

The original St. Teresa's School was built on the corner of Pennsylvania and Nineteenth Streets in 1912. In the 1960s, construction of the 280 Freeway weakened the building's foundation. The school was closed in 1966 and the structure was demolished. Compensating funds financed a new building at 450 Connecticut Street, which closed in 1974 due to low enrollment and financial difficulties. (Courtesy St. Teresa's Church.)

Enjoying a rare snowfall in December 1932 are Evelyn Strange, Florence Gallagher, and Marie Murnane in Marie's backyard at 343–5 Missouri Street. The three 13-year-olds attended St. Teresa's School on Pennsylvania Street and were on their lunch hour when this picture was taken. They often played one-foot-off-the-gutter and bought Italian bread at Maggioncalda's Market at 301 Arkansas Street (now Chatz Roasting Company). (Courtesy Carroll and Lyons families.)

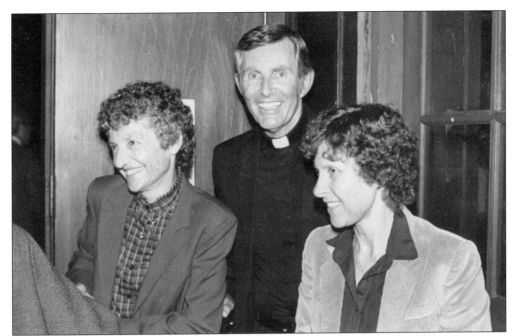

St. Teresa's Sister Kathleen Healy, Father Peter Sammon, and Sister Lucia Lodolo are pictured here in 1985. This pastoral team's commitment to social justice included participation in the Sanctuary Movement for El Salvadorean refugees, work with unions, the homeless, and efforts toward a living wage for city workers. (Photo by Lester Zeidman.)

In 2000, the congregation celebrated its 120 years as a parish. Father Sammon died in 2002; one year later, the block of Nineteenth Street in front of the church was renamed Peter Sammon Way. (Courtesy St. Teresa's Church.)

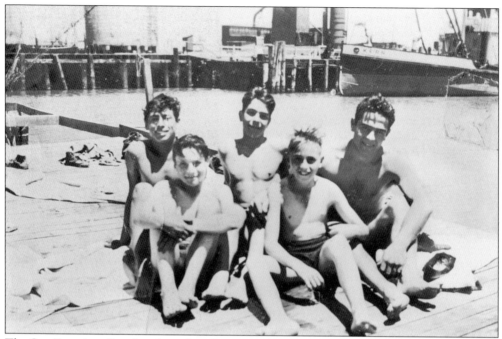

The San Francisco Bay shoreline along Potrero Hill was a popular place for kids to take a dip. Pictured in 1937, the teenagers of Tennessee Street, from left to right, are Tony, Pete, Augie Angeli, Hector, and Junior at the foot of Sixteenth Street, with the Loop Lumber Company pier in the background. (Courtesy Angeli family.)

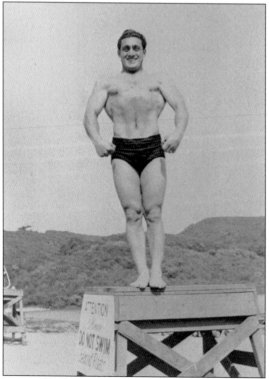

Known as "Moose," and later as "The Mayor of Potrero Hill," Amos Joseph Gallerani lived his whole life at 559 Texas Street. He could swim the length of an Olympic-sized pool underwater and played baseball into his 70s. His booming voice was unmistakable, and he knew everyone, everywhere—and if he didn't know you, he'd introduce himself. Hundreds attended his 80th birthday. Here's Moose in Calistoga in 1938. (Courtesy Whipple family.)

This plaque commemorating Tony Lazzeri hangs on the Lou Spadia clubhouse at Jackson Playground, bounded east and west by Arkansas and Carolina Streets, and north and south by Seventeenth and Mariposa Streets. Lazzeri played second base in the major leagues from 1926 to 1939 for the New York Yankees, Chicago Cubs, Brooklyn Dodgers, and the New York Giants. Nicknamed Poosh-'em-up Tony, he was the first big leaguer to hit two grand slams in one game.

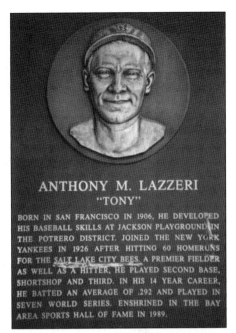

ANTHONY M. LAZZERI
"TONY"

BORN IN SAN FRANCISCO IN 1906, HE DEVELOPED HIS BASEBALL SKILLS AT JACKSON PLAYGROUND IN THE POTRERO DISTRICT. JOINED THE NEW YORK YANKEES IN 1926 AFTER HITTING 60 HOMERUNS FOR THE SALT LAKE CITY BEES. A PREMIER FIELDER AS WELL AS A HITTER, HE PLAYED SECOND BASE, SHORTSHOP AND THIRD. IN HIS 14 YEAR CAREER, HE BATTED AN AVERAGE OF .292 AND PLAYED IN SEVEN WORLD SERIES. ENSHRINED IN THE BAY AREA SPORTS HALL OF FAME IN 1989.

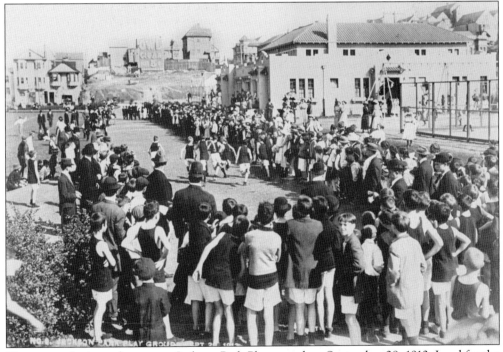

This image depicts a footrace at Jackson Park Playground on September 28, 1912. Land for the park, originally called Jackson Square, was set aside in 1855, but the site was virtually ignored until the 20th century. In the 1990s, the aging and overrun playground was renovated thanks to the efforts of the Potrero Hill Parents Association. Jackson Park Day—May 1, 1999—was declared by then Mayor Willie Brown in celebration of the renovation. Hill resident Ron Fiore arranged to refurbish the basketball courts at both the Jackson Park recreation center and the Potrero Hill Neighborhood House in 2004. (Courtesy Bonfiglio family.)

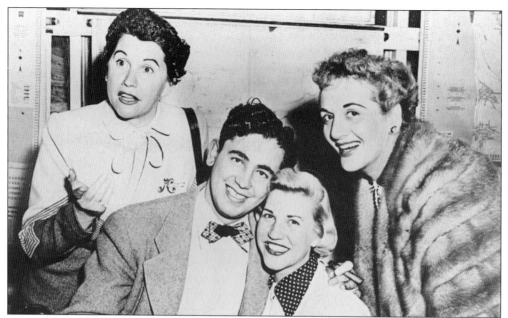

Sportswriter Al Corona is shown here in this 1949 image with the singing Andrews Sisters at the beginning of a career that spanned 42 years, many of them at the *San Francisco Examiner.* "We grew up together on Potrero Hill," said Lou Spadia, founder of the Bay Area Sports Hall of Fame and a former executive with the San Francisco 49ers. "He was a great fan, a good player, and a great role model for the kids on Potrero Hill. (Courtesy Corona family.)

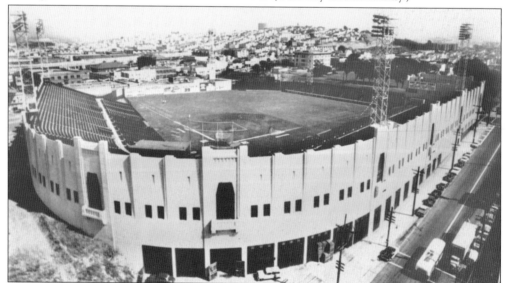

Seals Stadium opened at Sixteenth and Bryant Streets in 1931. It was home to the San Francisco Seals of the Pacific Coast League until 1957. Joe DiMaggio began his professional career with the Seals at age 17 in 1932 and went on to achieve fame as a New York Yankee in 1936. The fresh-from-New-York San Francisco Giants played their 1958 and 1959 seasons at Seals before the park at Candlestick Point was built. Seals Stadium was demolished in 1959. Today it is the site of the Potrero Center. Rumor has it that ghosts of the Seals occasionally haunt the aisles of the Safeway there late at night. (Courtesy Corona family.)

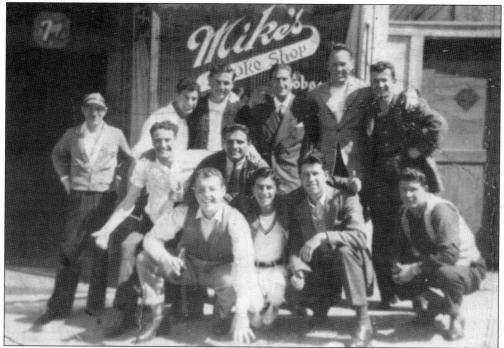

Mike's Smoke Shop, at 317 Connecticut Street (now Delirious Shoes), is shown here in 1939. Proprietor Mike La Grande is at the far left. (Courtesy Corona family.)

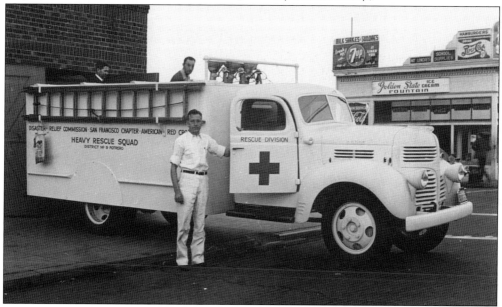

During World War II, the Potrero Hill Rescue Squad trained people how to give first aid in the event of an enemy attack, and stored this truck in the garage of Daniel Webster School. Bert Kloehn (standing), owner of Strand Service-Appliances, made a film, *Potrero Rescue Squad: A Mock Disaster*, that served as a model for other civil defense films. The ice cream fountain in the background is today the site of the Mani-Pedi nail salon on Twentieth and Missouri Streets. (Courtesy Judie Lopez.)

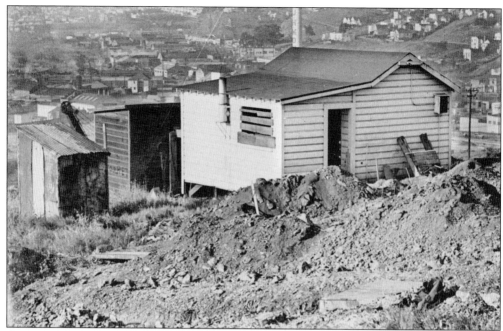

Cottages near Twenty-third Street await demolition in 1940 to make way for the construction of public housing. Roosevelt's Housing Act of 1937, designed to clear slums and provide low-rent housing, led to the establishment of the San Francisco Housing Authority. After the attack on Pearl Harbor that brought the country into World War II, the authority's priority was to create housing for the war-industry workers streaming into the city.

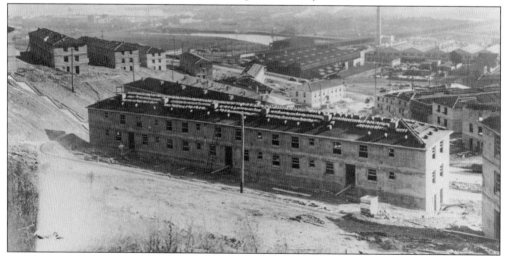

Four large projects were built on the Hill: Potrero Terrace shown here (469 units, at Twenty-third and Arkansas Streets), Potrero Annex (137 units, intended as temporary, at Twenty-second and Missouri Streets), Wisconsin Project (27 buildings, now demolished, at Carolina and Twenty-fourth Streets), and the Carolina Project. Federally mandated racial quotas for public housing to maintain "neighborhood patterns" were found unconstitutional by the Supreme Court in 1948. Author Kevin Starr, the late Enola D. Maxwell, supervisor Sophie Maxwell, actor Danny Glover, and activist Vera Mae Blue all lived for a time in Hill public housing. (Courtesy San Francisco History Center, San Francisco Public Library.)

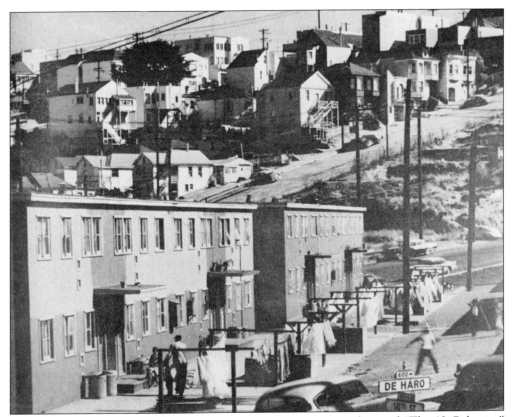

The 13 buildings of the Carolina Project public housing were nicknamed "The 13 Colonies." Bordered by Eighteenth, Nineteenth, Carolina, and De Haro Streets, they were torn down in the 1960s. The Potrero Hill Middle School opened on the site in 1971. The school was renamed the Enola D. Maxwell Middle School of the Arts in 2002. (Photo by Phil Palmer.)

This c. 1990 image depicts graduates of the Cleo Wallace Child Growth and Development Center in the Potrero Annex at 71 Turner Terrace. Sisters Kathleen and Lucia of St. Teresa's Church began a series of neighborhood meetings that helped identify specific community needs. This process, and the cooperation of government agencies, created The Oscaryne Williams Center of Hope for Infants, Toddlers and Families at 85 Turner Terrace in 1994. (Courtesy Oscaryne Williams.)

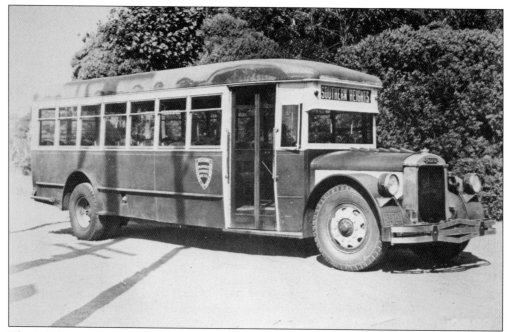

The Market Street Railway Company's No. 53 Southern Heights line began serving the Hill in 1932. Two six-cylinder coaches with leather seats for 30 ran on the route until 1940. The fare was a nickel. San Francisco Muni busses take the same route today. (Photo by Richard Schlaich.)

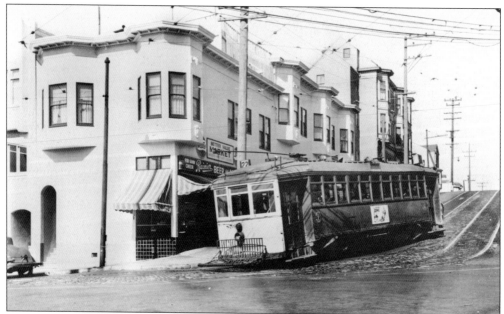

A White Front car on the Market Street Railway's No. 22 Fillmore line turns the corner at Connecticut and Eighteenth Streets in 1940. The white paint was a safety feature to make the cars more visible in the fog. The basket-like fender in front was intended to scoop up luckless pedestrians. Kids were tempted by a raised rear fender to cadge a free but precarious ride. (Photo by Tom Gray.)

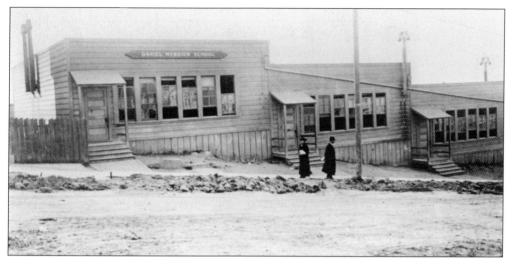

In 1909, Daniel Webster Elementary School opened its doors in a modest frame building on a lot bounded by Arkansas and Connecticut Streets between Nineteenth and Twentieth Streets. The school had six small, low-ceilinged rooms and an unpaved yard. It became home to the Potrero Branch Library after the school relocated to an imposing new brick building on Missouri and Twentieth Streets in 1917.

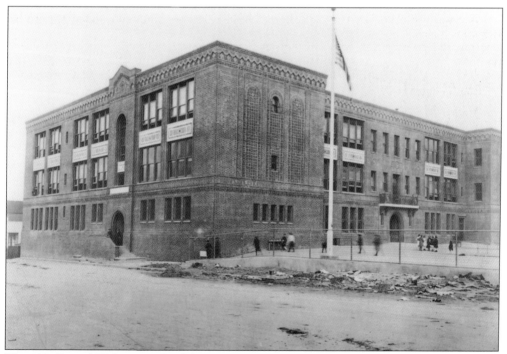

The 1924 Daniel Webster yearbook boasted that the new building had "twenty-one large rooms with plenty of ventilation and light. In each room there was a dressing area, telephone, new desks, radiators, and blackboards. They started cooking, sewing and millinery for the girls in the seventh and eighth grades and manual training for the boys. There is also a large auditorium." (Courtesy San Francisco History Center, San Francisco Public Library.)

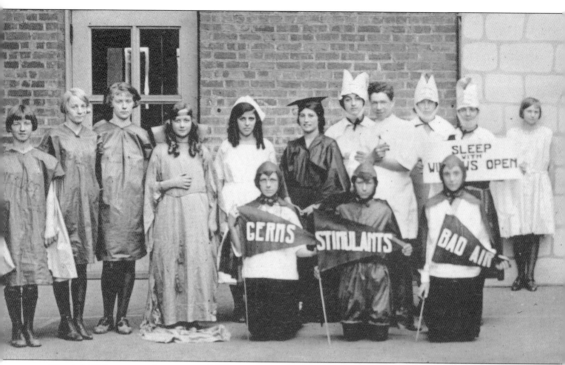

Daniel Webster students staged "Seven Keys: A Health Crusade Playlet in Three Episodes" in 1924. Health education was strongly emphasized in the years following the devastating influenza pandemic of 1918. (Courtesy Joan King.)

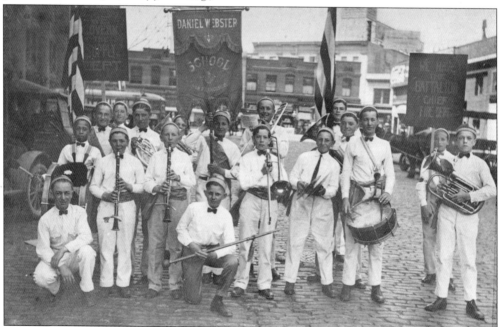

This c. 1925 image is of Daniel Webster's boys band at the foot of Market Street. The boy on the far left in the second row is Eddy Alley, getting an early start on his career as a professional jazz drummer.

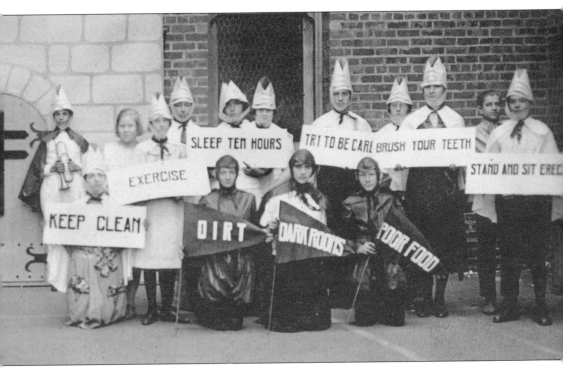

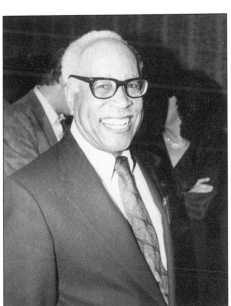

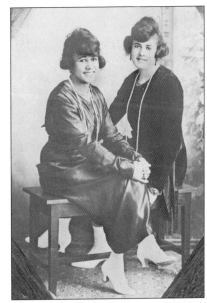

Eddy Alley (shown above left at a joint Daniel Webster and St. Teresa's School reunion in 1986) lived at 242 Missouri Street as a child. His was the first African American family to reside on Potrero Hill. Alley says that all races and nationalities got along well. Reminiscing with old classmate and bail bondsman Al Graff, Eddy recalled, "I didn't know you were Jewish!" "I didn't know you were colored!" replied Al. Eddy's mother, Toronto Alley (seated above right in front of family friend Aunt Gladys), worked as a hotel maid. His father, Eddy Alley Sr., had a hauling business. Many businesses at this time would not hire African Americans. (Courtesy Eddy Alley.)

The handsome brick Daniel Webster School was torn down in the 1960s. It was decided that an earthquake retrofit would be more expensive than a new building. Potrero Hillers have missed the old building ever since. The school auditorium, which was separate from the main building, remains today. (Photo by Stephen Fotter.)

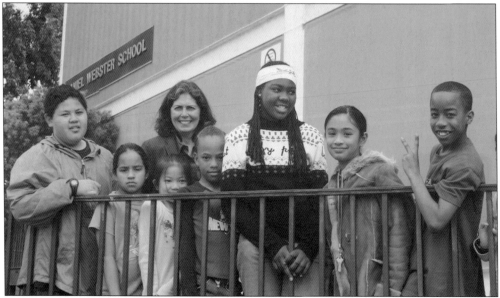

Today, there is a renewed sense of energy and purpose at Daniel Webster Elementary School under principal Adelina Aramburo. She says, "At Daniel Webster, we learn together, as learning is a life-long process." The K–5 program draws students from the Hill and surrounding neighborhoods. The school will celebrate 100 years on Potrero Hill in 2009. (Photo by Peter Linenthal.)

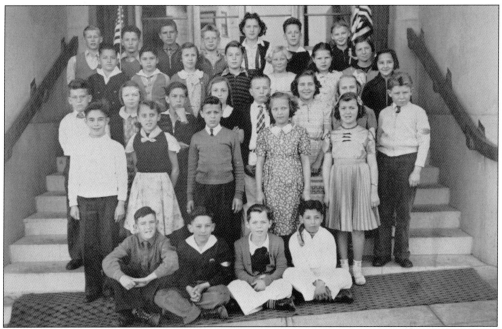

This image depicts Patrick Henry School students in 1939. The school at 693 Vermont Street opened in 1912 and closed in 1969. The building has housed the International Studies Academy Alternative High School since 1982. (Courtesy Pagan family.)

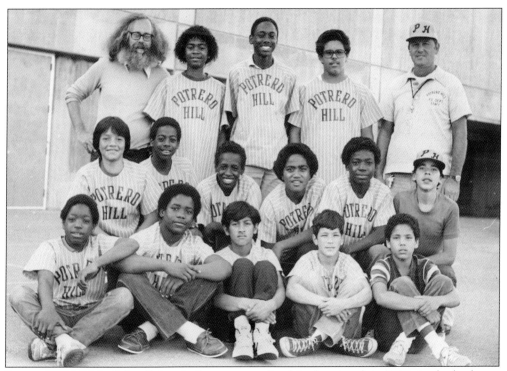

Potrero Hill Middle School's baseball team poses for this photograph in 1982. In the back row are coaches Jack Jacqua (far left) and Eugene Bagnasco (far right). (Courtesy Jack Jacqua.)

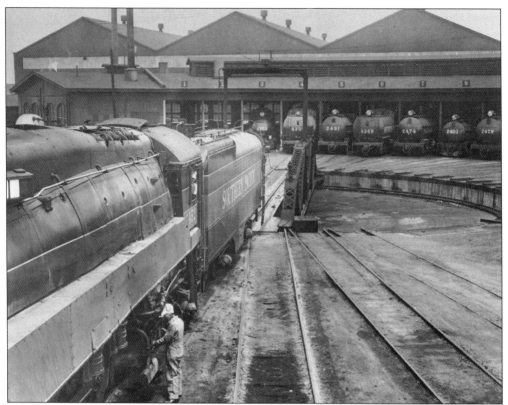

Southern Pacific's roundhouse at Mariposa and Tennessee Streets was built in 1906 and closed in 1960. The streets at the base of Potrero Hill were crisscrossed with tracks for trains carrying both freight and passengers into the city. (Courtesy San Francisco History Center, San Francisco Public Library.)

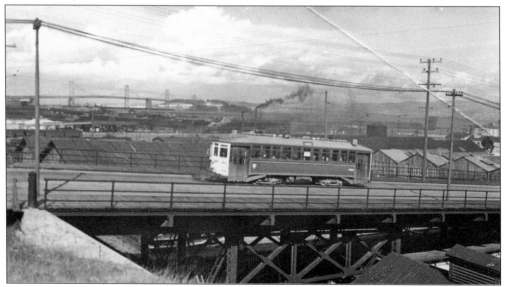

Shown here in the 1940s is the Market Street Railway's No. 22 Fillmore line streetcar on the Eighteenth Street viaduct. (Photo by Tom Gray.)

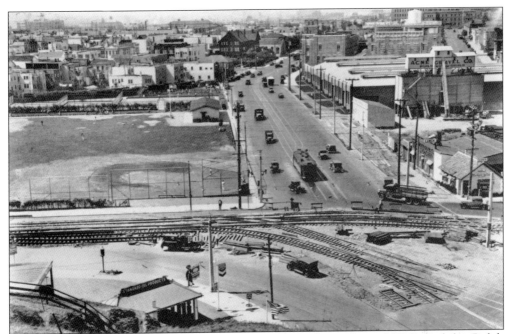

This view looks north up Potrero Avenue from Bernal Heights in the mid 1920s. At left is Rolph Park's baseball diamond. At right is the Acme Gravel Company, with Knudsen Dairy beyond (now Knudsen-Bloom Park). A stone wall built by Native Americans from Mission Dolores once crossed this area. (Courtesy Jack Wickert.)

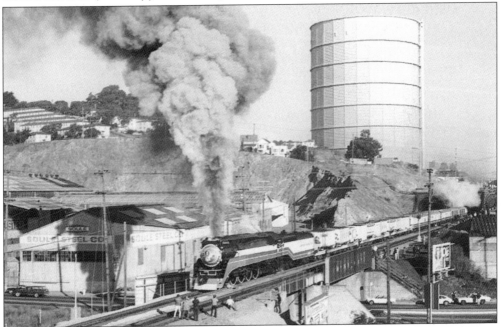

A Freedom Train, one of several celebrating the 1976 bicentennial, crosses a trestle over Army Street. This steam locomotive once pulled the Southern Pacific *Daylight* between San Francisco and Los Angeles. The landmark PG&E tank was demolished in 1989. (Courtesy W. C. Whittaker.)

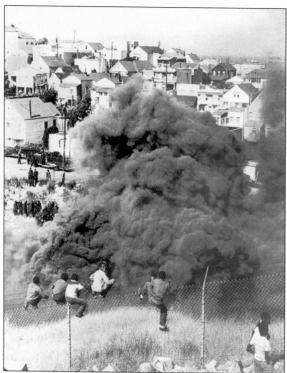

Western Pacific built a train tunnel running from Twenty-second Street and Texas northwest to Arkansas and Eighteenth Streets in 1907, bringing trains to their depot at Ninth and Brannan Streets. Kids made a game of running through the tunnel or hanging onto the backs of trains as they passed through. A fire in 1962 weakened wooden supports in the tunnel. (Courtesy *San Francisco Chronicle*.)

Street cave-ins were the result of the weakened wooden supports; here is one at Arkansas and Nineteenth Streets. There was another on Missouri Street at Twenty-second Street, a fact that came as a surprise to a loan applicant on a piece of property there years later. The tunnel was sealed off and filled in after the fire. Just beyond the hole is the Carolina public housing project.

This building at 772 Rhode Island Street was built in the 1880s by a Mr. Daly, who hauled lumber with two teams of horses he kept in a nearby barn. It may have been the first house on the street. Tenants reported hearing the noises of ghostly card games. It was torn down around 1976. (Courtesy *The Potrero View*.)

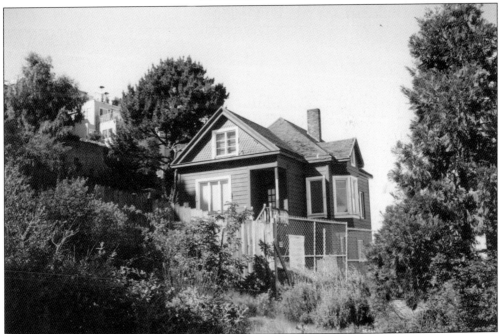

"The Little Red House" at 690 De Haro Street was built in the 1880s by Amos McCarthy, a wealthy gold rush pioneer. A dip in the hill just to the east (where the Enola D. Maxwell Middle School stands today) was then known as Chili Coot Pass. Anna Buck, longtime Hill activist, lived in the house for many years before it was threatened by development. In 2001, 530 neighbors signed a petition in an effort to save the house (and its adjacent butterfly garden), to no avail. An apartment complex now occupies the site. (Courtesy Deutsch family.)

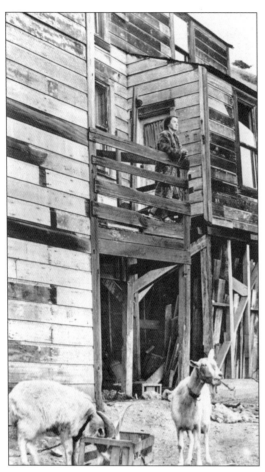

On April 28, 1951, Mrs. Estelle West stood "defiantly on her porch as some of her 18 goats munch on their breakfast of greens." She was forced to sell her home and goats as the State Division of Highways needed her property at 705–707 Utah Street for construction of the James Lick Freeway (Highway 101), which was completed in 1953. Many residents remain bitter about the low payments made to those forced to sell their homes (Mrs. West received $3,950), and about the physical barrier dividing their community. (Courtesy San Francisco History Center, San Francisco Public Library.)

When another freeway for the Hill, to the east, was proposed in the 1960s, there was strong neighborhood opposition. Yet the 280 Freeway was completed in 1973, destroying this row of houses on Iowa Street south of Eighteenth Street. (Courtesy *The Potrero View*.)

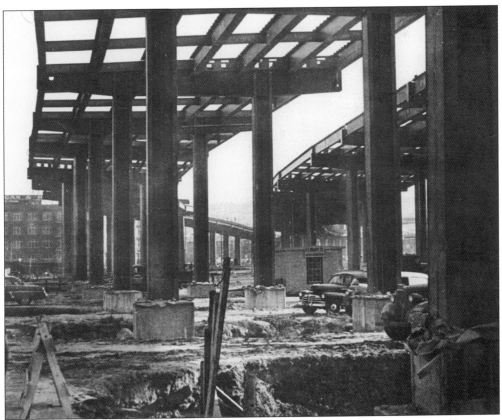

Highway 101 nears completion just north of Sixteenth Street in the early 1950s. (Courtesy Banchero family.)

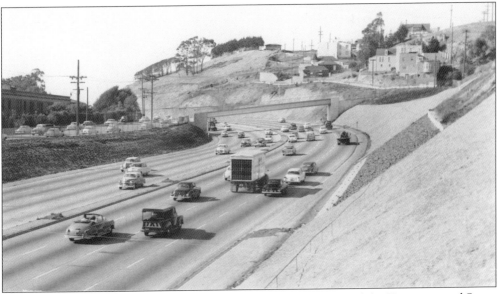

This view looks north along the newly completed Highway 101 toward the Twenty-second Street pedestrian bridge, with the trees of McKinley Square on the horizon. (Courtesy Tom Gray.)

Poet Allen Ginsberg is seen here in 1955 typing (possibly the *Howl* manuscript) at Peter Orlovsky's apartment at 5 Turner Terrace, Potrero Terrace Project. *Howl* changed the world's expectations of poetry and overcame censorship trials to become one of the most widely read poems of the century. (Photo by Peter Orlovsky; courtesy Department of Special Collections, Stanford University Libraries.)

In 1957, Lawrence Ferlinghetti (right) bought this house at 706 Wisconsin for $9,995. He is a poet, painter, publisher, and cofounder of City Lights Books, America's first all-paperback bookstore. It continues as a center of San Francisco's literary life. In this *c.* 1960 photograph, he stands with Jack Kerouac, whose novel *On the Road* came to symbolize the unconventionality of the beat generation. (Photo by Kirby Ferlinghetti; courtesy Bancroft Library, UC Berkeley.)

Kay Cole worked throughout her life to improve conditions for the underprivileged and American Indians. In the 1960s, she helped organize the march against the war in Vietnam, which culminated in thousands of people gathering in Golden Gate Park. For many years she was active at the Neighborhood House. Her second husband, screenwriter Lester Cole, was one of the Hollywood Ten who were blacklisted and jailed for refusing to answer questions about their political beliefs before the House Un-American Activities Committee in the 1940s. (Photo by Bob Hayes.)

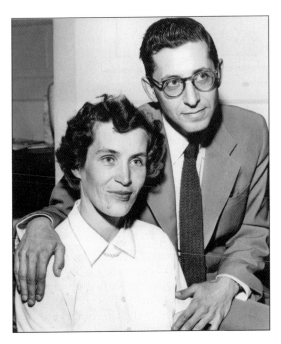

During the red-baiting 1950s, John and Sylvia Powell were accused of treason and sedition over articles they had published while living in Shanghai. After their return to San Francisco in 1953, they found it difficult to pursue their writing and editing careers. They bought an old house on Potrero Hill, fixed it up, sold it for a profit, bought another, and did the same thing. After all charges were dismissed in 1961, a huge party was held at 1301 Rhode Island Street, one of fourteen houses (many on Potrero Hill) and several apartment buildings they bought, rehabilitated, and sold when other job opportunities were denied them because of the notoriety of their case. The Powells are shown here in 1958. (Courtesy *San Francisco Chronicle*.)

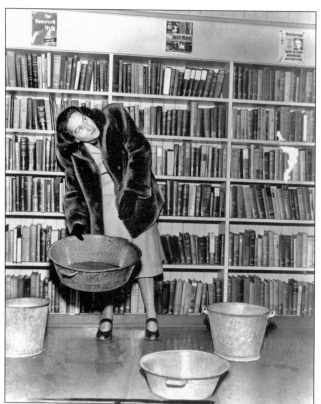

Librarian Marion McCarthy is shown here in December 1948 catching rain leaks in an assortment of buckets and pans at the Potrero Branch Library when it was at 448 Connecticut Street (and called the Potrero Heights Branch). A notation on the back of the photograph reads: "City Librarian Lawrence J. Clarke said the library . . . would be closed and its books stowed until at least the end of wet season."

In June 1951, the library moved into a new building at 1616 Twentieth Street. The branch is scheduled to close for renovation and expansion in the summer of 2006 and to re-open in 2008. (Courtesy San Francisco History Center, San Francisco Public Library.)

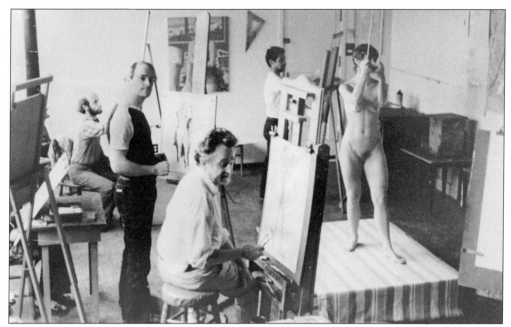

Painter Charles Griffin Farr (center at easel, in 1984) lived in a cottage at 733 De Haro Street where he led Monday drawing classes for over 30 years. He started the annual Potrero Hill Artists Exhibition, which celebrated 50 years at the Potrero Branch Library in 2005. Hill views often appear in his work in a style described as timeless realism. (Courtesy the late Charles Griffin Farr.)

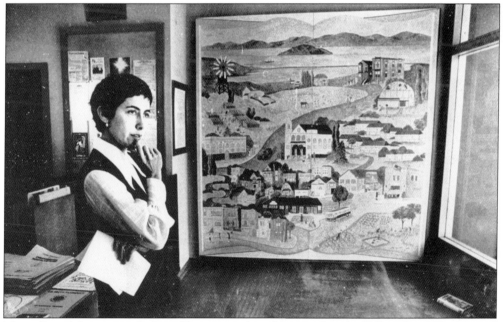

Margo Bors did not consider herself an artist when she moved to the Hill in the 1960s. Inspired by the many artists who were her new neighbors, she became one too. Now a well-known printmaker, painter, and photographer, she painted this mural depicting Hill history at the entrance of the Potrero Branch Library in 1982.

Painter, printmaker, and teacher Robert Bechtle is considered one of the founders of Photorealism. Using the camera as an essential tool, he favors what he calls "California subject matter"—the people, cars, and streets of sunlit middle-class neighborhoods. Recently, he has concentrated on Potrero Hill, where he lives with his wife, author and professor of art history, Whitney Chadwick. This etching, *Texas and 20th Intersection* (2004), combines both immediacy and timelessness, objectivity and a quiet power. (Courtesy Robert Bechtle and *Crown Point Press*.)

Sculptor Ruth Cravath, shown here with helper Mark Wasco, created this statue of Thomas Starr King in 1956. The statue stood originally in front of Starr King Elementary School on Carolina Street, but was moved to the First Unitarian Church on Franklin after it was vandalized. She called this statue her favorite work. Ruth lived at 389 Wisconsin and worked in a stoneyard nearby. (Courtesy San Francisco History Center, San Francisco Public Library.)

Potrero Hill had its own 300-seat movie house from 1913 until 1963 on Connecticut Street near Eighteenth Street. In its early years, it was called the Alta Nickelodeon and showed silent films to the accompaniment of a player piano. Free food was served on Saturday nights. Sadie Meyer remembered buying candy at Wulzen's Pharmacy (now Christopher's Books) on Eighteenth and Missouri Streets on her way to see *The Perils of Pauline*. From 1929 to 1963, it was the New Potrero, but known as the Nick or the Fleabag. Longtime residents remember a weekly "Dish Night, Free to the Ladies." Since 1963, the building has had a variety of occupants and uses. It is now home to the Gurdjieff Society. (Photo by Tom Gray.)

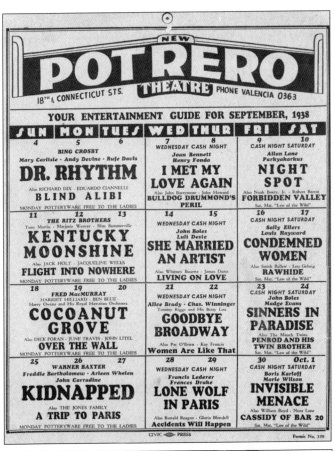

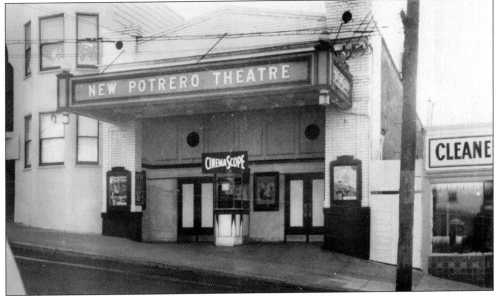

The Grateful Dead rehearsed material for their album *Anthem of the Sun* at the defunct New Potrero Theater in 1968. Malcom Lubliner took this photograph of, from left to right, Phil Lesh, Bill Kreutzmann, Jerry Garcia, Bob Weir, and Mickey Hart for *Teenset* magazine. (Courtesy Michael Ochs Archives.com with permission of Grateful Dead Productions, Inc.)

Potrero Hill's dramatic views and wide, relatively uncrowded streets have attracted many filmmakers and producers of television shows and commercials. This shot from the famous chase scene in *Bullitt* (1968) looks north on Kansas Street at Twentieth Street. (Courtesy Warner Brothers.)

Other films featuring Potrero Hill include *Dirty Harry* (1971), *Magnum Force* (1973), *Freebie and the Bean* (1974), *Chu Chu and the Philly Flash* (1981), *Burglar* (1987), *Pacific Heights* (1990), *Copycat* (1995), *Homeward Bound II* (1996), *EDTV* (1999), and *Groove* (2000). This is a shot of *Sweet November* (2001), starring Charlize Theron and Keanu Reeves, with Eighteenth Street, Missouri Street, and Farley's ("Community in a Cup") coffeehouse in supporting roles. (Courtesy Warner Brothers.)

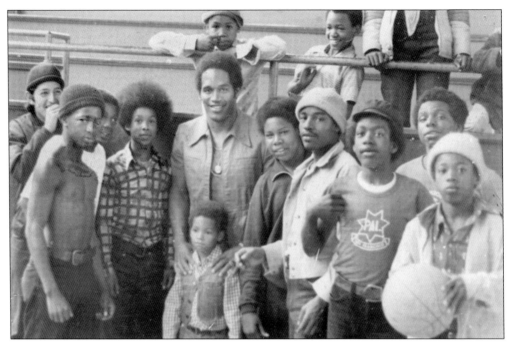

The Potrero Hill Recreation Center at 801 Arkansas Street has been serving Hill youth since the 1950s. Here famed football player O. J. Simpson, who grew up on the Hill, returns to present awards to recreation center champions in the late 1970s. (Courtesy Potrero Hill Recreation Center.)

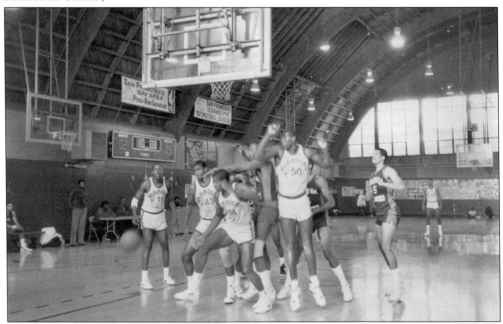

Jon Greenberg, recreation center director since 1966, initiated the popular pro-am basketball games in the center's gym in 1970. The program continued there for 17 years before moving to Kezar Stadium. In this 1987 exhibition game, the Pro-Am All-Stars beat the Summer Warriors, 129-118. (Photo by Ruth Passen.)

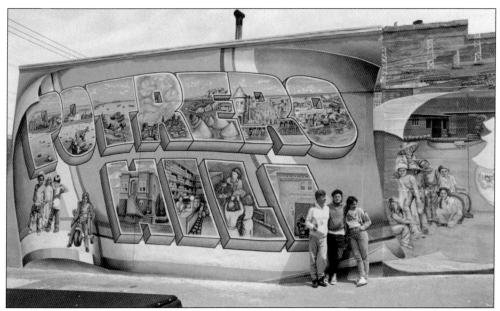

Muralist and project director Nicole Emmanuel (right) stands with assistants Dan Fontes (left) and Scott Branham in front of the 1,500-square-foot mural depicting the multi-cultural history of Potrero Hill that they painted at Connecticut and Seventeenth Streets in 1987. (Photo by Lester Zeidman.)

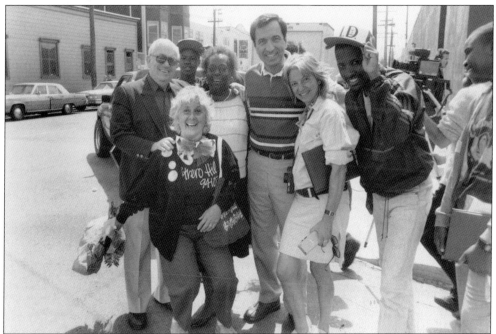

A block party was held to dedicate the mural to the neighborhood. Ruth Passen (editor of *The Potrero View*) stands in front of longtime Hill resident Jimmy Herman, president of the International Longshore and Warehouse Union. On Jimmy's left is community worker Betty Brooks, and on Betty's left is Art Agnos, a resident of Connecticut Street who would be elected mayor of San Francisco later in the year. (Courtesy Ruth Passen.)

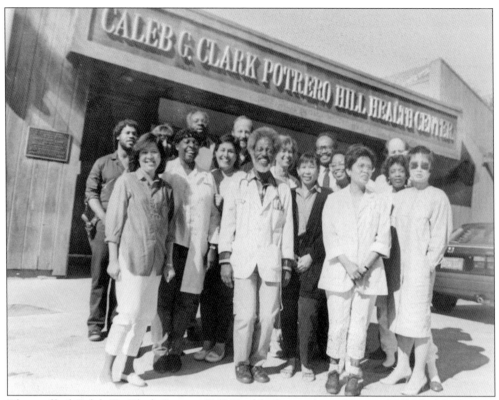

The staff of Caleb G. Clark Potrero Hill Health Center (now Potrero Hill Health Center) celebrate the clinic's 12th anniversary in 1988. The clinic was started through the efforts of neighborhood activists and has taken care of several generations of families in one of the city's poorest communities, the Hill's south slope. (Photo by Bob Hayes.)

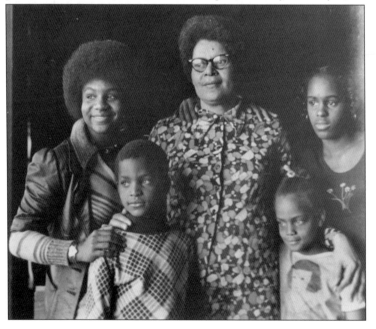

Hazel Smith poses for a shot with her grandchildren, from left to right, Renee and Tracy Baldwin and Leroy and Kuzuri Jackson at the family home on Missouri Street in the 1970s. Today, "Kuzuri of Missouri" is deputy director of the Neighborhood House. (Courtesy Renee Baldwin Strong.)

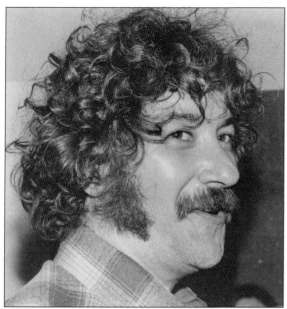

In 1975, Philip DeAndrade opened Goat Hill Pizza at 300 Connecticut Street. Goat Hill's sourdough crust, views, display of historic photographs of the Hill, and fund-raisers for St. Teresa's Sanctuary Movement, CISPES, and other sundry good causes has made it a neighborhood institution. While Goat Hilda no longer lives in the backyard, Phil still lives on a Mission Creek houseboat. (Courtesy Philip DeAndrade.)

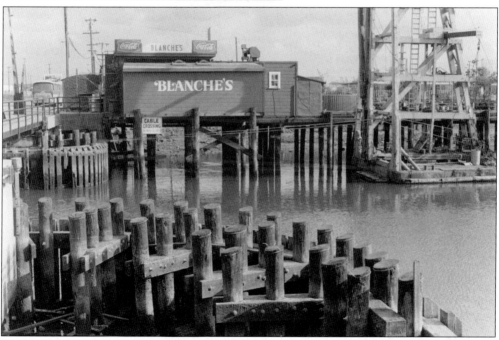

In 1959, Blanche Pastorino bought a one-room saloon catering to longshoremen—a 100-year-old shack on Mission Creek at Fourth and Channel Streets—and transformed it into the funky-chic Galerie de Blanche. She hung paintings on the walls, set daisies on the rough tables, and replaced the jagged tops of coffee tins the men had been using as ashtrays with abalone shells. For 28 years she served light prix fixe lunches ("my limited repertoire," she called the menu) and white wine to a diverse clientele of writers, artists, society folk, downtown suits, and locals. She added a room with lots of windows to the north, but the preferred place to dine was on the pier, amidst potted trees that Blanche planted herself. They were the only trees in the neighborhood. (Photo by Stephen Fotter.)

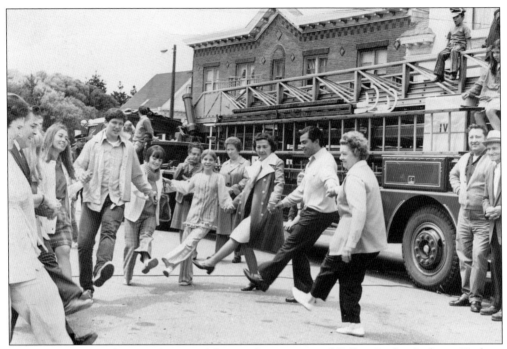

The Potrero Beautification Group celebrates the opening of Fallen Bridge Park on Utah at Eighteenth Street in June 1971 after the pedestrian bridge there was hit by a crane on a truck. The high steppers, from left to right, are Doris Lovrin, Dick Volland, Wendy Drefke, John Lovrin, Maxine Zak, Nell Cunningham, Robin Volland, Babette Drefke, then supervisor Bob Gonzales, unidentified, Rudy Sustarich, and Martin Schukle. (Courtesy Sustarich family.)

In the 1970s, Potrero Hill green thumbs created a community garden on park department land just north of McKinley Square. With half of San Francisco as its backdrop, the garden flourishes to this day. (Photo by Stephen Fotter.)

When development threatened a vacant half block on Arkansas Street between Eighteenth and Nineteenth Streets in 1990, neighbors organized to create a park there, The Potrero Commons. Anchor Brewing Company produced a special Potrero Commons Ale as a fund-raiser. There were parades and posters, and a totem pole and teepee were erected on the site. Development prevailed, but the artists' live-work space, which opened in 1996, is different from many of the developments fueled by the 1990s dot-com boom. Called Goodman 2, this one has variety and open space. It also houses artists displaced in the 1980s from the Goodman Building on Geary Street, Thick Description Theater Company, and an outdoor amphitheater. Earlier efforts to preserve open space failed when Victoria Mews rose on the block bounded by Twentieth, Carolina, Nineteenth, and Wisconsin Streets in the late 1970s, but succeeded in saving Esprit Park on Minnesota Street in 2001. (Photo by Peter Linenthal.)

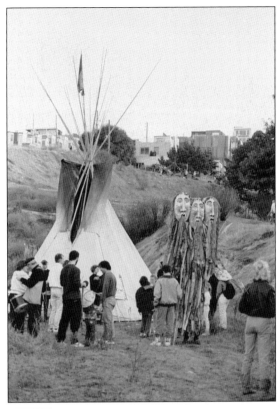

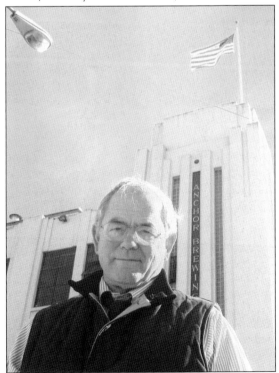

Fritz Maytag, the great grandson of the founder of Maytag Appliances, bought 51 percent of the venerable but struggling Anchor Brewing Company (established in 1896) in 1965 for a few thousand dollars. Maytag became the sole owner of San Francisco's oldest brewery in 1969, and two years later began bottling the steam beer that had been sold only to restaurants and bars as draft. In 1979, the old Chase & Sanborn coffee roastery at 1705 Mariposa Street—just blocks away from a former Anchor location at Seventeenth and Kansas Streets—became Anchor's new home. Anchor Steam Beer and the brewery's other unique beers and spirits, brewed and distilled by traditional methods, are known around the world; Anchor is highly regarded on the Hill for its involvement in community issues and activities. (Photo by John Borg.)

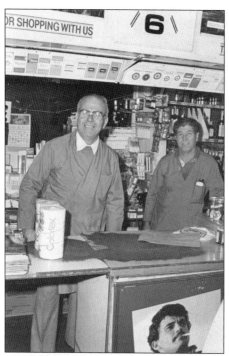

Jim Khuri (left) and Al Shami came to the United States from Palestine in 1956. In 1960, they took over the New Potrero Market, at 1301 Eighteenth Street, and transformed it into "a little Safeway." However, Jim and Al's provided service unlike any Safeway in special ordering, extending credit, and even serving as something akin to a mini bank in the days before ATMs. Al's specialty was the produce section, which he kept sprinkled and tidy throughout the day. They sold the business in 1999. (Photo by Stephen Fotter.)

Potrero Hill residents mourned the closing of Atchison's Pharmacy, at 1607 Twentieth Street, in December 1995—a victim of cost-cutting practices in the health insurance industry that left no room for small, independent neighborhood drug stores. Cliff Wong (who worked at Atchison's for a total of 33 years) and his wife Bernice bought the pharmacy after owner Dave Bonelli's retirement in 1987. (Photo by Vas Arnautoff.)

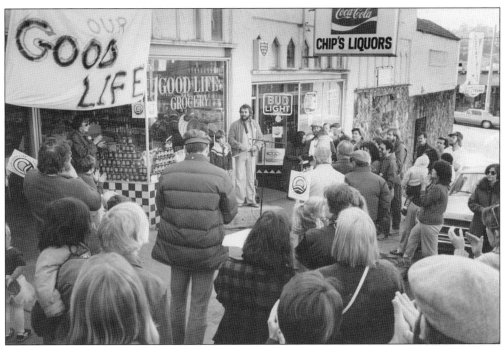

The Good Life Grocery opened at 1457 Eighteenth Street in 1974. In 1985, neighbors joined forces to "Keep Our Good Life" when owners Lester Zeidman and Kayren Hudiburgh faced a rent increase of over 1,000 percent. The store closed in September and reopened at 1524 Twentieth Street in March 1986. The Eighteenth Street storefront remained vacant for more than eight years. The Good Life staff is shown in the Eighteenth Street store on the very day Lester and Kayren signed the lease for the new store. Pictured, from left to right are the following: (seated) Jazmine, Linda Sciera, Lori Samz, and Amy Zeidman; (standing) Kayren, Bob Gervasio, Michaelle Goerlitz, Ray Hansen, and Lester. (Photo by Lester Zeidman.)

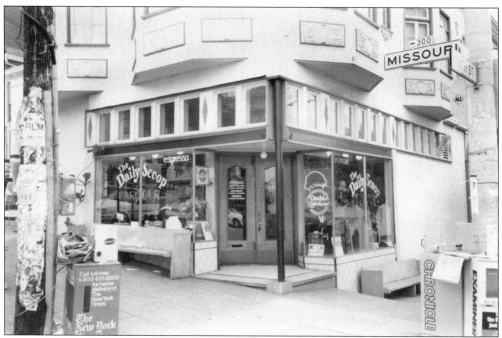

The Daily Scoop Ice Cream Parlour opened at 1401 Eighteenth Street in 1978, featuring a jukebox and 1950s soda fountain-related memorabilia. It became a popular neighborhood hangout for all ages before closing in 2001. Chez Papa Bistro opened on the site in 2002, adding a French accent to the neighborhood. (Photo by Ruth Passen.)

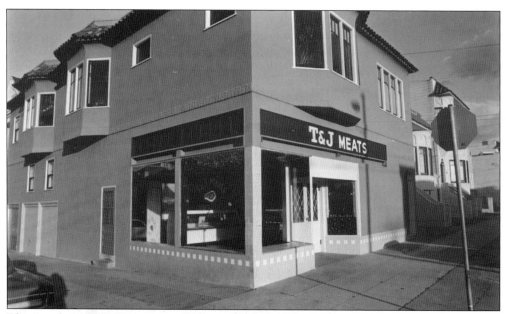

This is a shot of 501 Connecticut Street in the late 1970s. Before T&J Meats, there was M&M Meats, and before M&M, there was Bizio's Grocery, which closed in 1948. Klein's Deli has been serving handcrafted sandwiches named after famous women at this address since 1979. (Photo by Stephen Fotter.)

The first issue of *The Potrero View* appeared on August 1, 1970, and was "published monthly by The Potrero Hill Mob . . . in the hope that Potrero Hill might come together." In this 1979 staff photograph, Vern Huffman holds up a copy of the paper with its distinctive masthead, designed in 1973 by Hill artist Giacomo Patri. At the far right is Ruth Passen, a staff member since 1971 and editor since 1978. Bob Hayes, the paper's photographer for many years, is in the back row, at the far right; and in the back row center is Vas Arnautoff, a staff stalwart from 1977 until his death in 1998. The award-winning, all-volunteer *View* is a true community newspaper, drawing its inspiration from the diverse talents, interests, and concerns of the neighborhood it serves.

In 1986, Julie Gilden and neighbors started The Potrero Hill Archives Project, recording oral histories with longtime neighborhood residents, copying historic photographs, and producing videos on Potrero Hill history. The archives' collection can be seen at the Potrero Branch Library. In October 2000, the Archives Project and The Potrero Hill Association of Merchants and Businesses cosponsored a Night of Potrero Hill History. It has become an annual event, featuring interviews with longtime Hill residents, videos, and displays of old photographs and Hill artifacts. Here, Abigail Johnston, managing editor of *The Potrero View,* and Peter Linenthal, curator of the archives, are costumed for History Night 2003, at which they announced the signing of the contract for this book. (Photo by Stephen Fotter.)

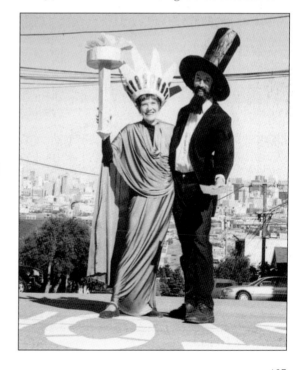

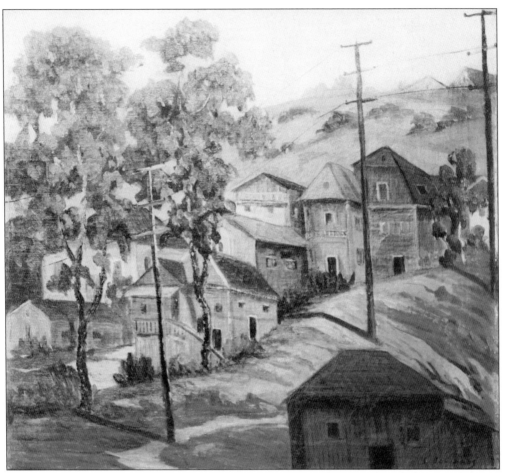

Here is a c. 1920 view of Potrero Hill by landscape artist Lionel Louis Edwards (1874–1954). It is hard to tell exactly what spot on the Hill is seen here (tell us if you know), but this painting is loved by all. It seems to show the Hill in the midst of change. Clusters of homes climb the steep slopes, surrounded by pasture. The scene glows in sunlight—Potrero Hill often escapes the fog that shrouds other San Francisco neighborhoods. The 1990s dot-com boom sent property values through the roof. Boxy live/work studio apartment buildings sprouted everywhere. Intended for artists and craftspeople, they went to wealthier buyers, earning the nickname "lawyer lofts." The splendid baseball park at China Basin, the new 43-acre research campus of the University of California, San Francisco at Mission Bay, and the Third Street Light Rail are bringing even more people, and much more attention, to a neighborhood that not too many years ago was considered a sleepy backwater, hardly part of San Francisco at all. You can't say that anymore! In 1949, A. J. Blumenthal, columnist for the *San Francisco News–Call Bulletin*, described Potrero Hill, and it is fitting to give him the last word:

> If you want to be literal, Potrero Hill is situated just south of downtown, west of outer Third Street and east of General Hospital. To put it another way, it's at the intersection of View, Warmth, Isolation, Economy, and Honesty. These are the ingredients which make Potrero Hill into something more than a place and close to a religion.